I Promise Not To Tell

By
Brenda M. Weber

PublishAmerica

Baltimore

First printing

ISBN: 1-4137-0427-1
PUBLISHED BY PUBLISHAMERICA, LLLP
www.publishamerica.com
Baltimore

Printed in the United States of America

I am dedicating this to
my twelfth-grade English teacher,
Betty LaPointe.
She delicately helped me recognize my passion for writing.
She taught me to express my smoldering feelings with
honesty and no regret.
We are not human if we can't openly express our feelings.

CONTENTS

Faye—

Best Wishes

from a U.P. author—

Robert M.
Weber

INTRODUCTION

As I look into the mirror of my life, I see the child I was and wonder how I became the woman I am. Every aspect of my life reflects back to my childhood as it trails behind me. Everything that happened to me as a child has affected many different attitudes and aptitudes of my being. My heart cannot comprehend how every vein that extends from that pulsing mass of muscle leads back to the same heartless act, the violation of my innocence.

I have always had a hard time remembering anything from my childhood, especially the years before my ninth birthday. Those fragments are only triggered as memories by looking through old photographs or listening to others tell of their memories, but when I was sixteen, some of those memories took the form of a mass of blurred and soiled shapes in a disoriented picture.

I had no allowable control to stop anything that happened to me, just as I have no allowable control now, to stop any of the heart-wrenching pictures of reality that flash through my mind. I know the human brain, with all its intricacies, has a safety defense to keep me from going insane, and isn't the line between sanity and insanity so delicately thin? Haven't we all walked that tightrope, precariously balancing somewhere in the middle, ready to fall off the wrong side at any given moment?

This book is for anyone who has lived with the pain of child abuse. For anyone who has lived with the pain of domestic abuse, either physical or emotional, for anyone who has survived or will survive from the pain of remembering, and for the memory of those who haven't survived.

For me, to try and recapture it all by attempting to understand is painfully senseless. To try and put the pictures together and have to see myself in those pictures, is painfully senseless. It is all painfully senseless, but in order to make any sense at all, I must get past the pain.

I was an invisible child – seldom seen, never heard. As an adult, I can either make the invisible child visible, or send her entity into the realm of nonexistence forever. The little girl that haunts my life, by wandering aimlessly through my thoughts, is wearily searching for her own peaceful niche. She will continue to haunt me, unless I make an adult decision to reveal the secrets I promised not to tell – and live with the memories that have been silently waiting for justification.

My story is truth, to the best of my collective memory. It is written with a touch of relish, a lot of mustard, and names have been changed to protect the innocent, and not so innocent. If you recognize yourself, it might not be you. You can ask me if it's you, but I promise not to tell.

DON'T TOUCH

I didn't feel the cold barrel of the gun when it was placed to my head, but suddenly from out of nowhere, freak paranoia crept into my existence. I couldn't fend off the overwhelming urge to bolt from the car. My breathing began to respond to the claustrophobic veil that was being drawn across my face in a feathery motion. As I started gasping for air, my heart was ferociously trying to pound its way out of my chest. My skin was crawling with tainted obscenities.

This was the first date with Luke. We were sitting in his car in front of my house. I had been infatuated with Luke from the first time I saw him, and was ecstatic when he asked me out. When Luke leaned over to kiss me, I thought my heart would melt. When things began to heat up, I knew I had to resist letting his caresses persuade me into doing something I didn't want to do. I was not a virgin, but I did not want Luke to know, I wanted him to like me for myself, and not because he might be able to have sex with me. I felt special with Luke, and my need to feel loved might be the only reason why I might give in to his desirable kisses.

Luke was several years older than me, and at sixteen, I was not one of the popular girls in school. What made others popular were the cliques they bonded with, and some were party sluts or jock jumpers. I was not pretty, just plain. My brown hair hung fine and stringy past my shoulders, my crooked smile hid my less than perfect teeth. I was thin, but my breasts were tantalizing and noticeable. My

deep brown eyes were hidden behind glasses, bedroom eyes I had been told more than once. Enjoying the passionate kiss, Luke caught me off guard when he impulsively grabbed my hand, drawing it with a spontaneous jerk, placing it on the front of his jeans where his hardness was evident. His penis was as hard as the barrel of the gun, and the cold feeling of terror momentarily dazed me. I had never touched a man's penis before, *what was he doing?* The words were screaming inside my head, bouncing off the interior of the car, "Don't make me do this, please don't make me do this!"

In reality – there was no gun – but at that moment, a trigger went off in my head, playing a game of Russian roulette that sent a whirl of pictures flashing before me. A repressed memory bolted into my head with the deafening roar of a crashing wave that was intent on drowning me under its immense power.

I felt weak and under total control of Luke, whom I thought was a gentleman, until now. I struggled to get away from his icy grip and wipe the violated feeling from the palm of my hand. I didn't know if the screams burning my throat were actually escaping into the darkness, or if they were trapped within the closet of my memory. As I groped around in a state of frenzy for a door handle that didn't seem to be a part of the door, I realized my screams were an audible part of the fear that held me like a corpse. I could hear Luke pleading, "I'm sorry, I'm sorry, what the hell is wrong with you!?" A black fog was beginning to close in on me as the door handle finally gave in to my desperate clawing. The door flew open and the cold night air hit my nostrils, giving me life again. I was free. Run.

As I scrambled from the car, I felt like everything was going in slow motion. I was running through a pressure chamber that was deformed by searing tears streaming down my face. I felt curdles of vomit at the back of my throat being forced up by screams hidden away from my childhood. *What the hell was going on?*

As I struggled to answer my own question, pictures continued flashing before me in color bursts. I could see the layout of a house I had been in as a little girl. I could never remember what the inside of the house looked like, until now. I felt like I was there again, and

trapped inside the house that had burned down many years before.

By the time I reached my front door, the full recollection of being molested in that house all came back to me, all because of Luke trying to force me to touch him in a place that threatened me. The aggressive way he had gripped my hand and guided it to his penis in one quick movement, was enough to stimulate the trigger of my memory.

I began to understand the snag in the thread that had run prevalent throughout my adolescence. Years filled with incest, lesbianism, dirty games with boys, and a persistent man's pursuit in trying to initiate me sexually by *popping my cherry*. A thread that would continue on throughout my adult relationships, and eventually become the tangled mess that is me, and now I am driven to unravel it.

The clarity of my memory is as if I were actually floating above the scene and being a silent witness to it, instead of the victim, the victim of a very cruel plot to invade my innocence at the age of four.

On one of my weekend visits to my aunt and uncles, I was lured into a bedroom by my sister and a girl cousin. Another cousin, Kevin, was waiting in a closet. Pillows and blankets had been arranged on the closet floor, and Kevin was lying there waiting for the girls to bring me to him. They wanted me to get in the closet and lay beside Kevin. They said they would not let me out of the bedroom until I did. I was afraid of the older boy, but I did as I was told. I was terrified when they closed the door and I was in the dark. I started to cry, but Kevin kept telling me I couldn't go until I pulled down my panties. I did.

Kevin pulled down his pants and wanted me to touch him. I didn't want to do it. I was crying, and wanted out of the closet. The darkness was smothering the very breath out of me. I didn't want to touch Kevin. He finally grabbed my tiny hand and made me touch his penis. I closed my eyes and hoped someone would come and rescue me. I could hear the two girls giggling on the other side of the door. I didn't like the feeling of Kevin's *thing* in my hand. It was hard, and he was moving my hand with his, rubbing and stroking himself. Kevin was touching my private parts, his fingers moving over the soft folds

of skin where no one should be touching, while I was holding his penis, crying, and stifling screams for help.

The closet door finally opened, and they let me get out and pull up my panties. Before they let me out of the bedroom, they made me promise not to tell. I had promised, and because of whatever mechanism in my brain that shut it out, I had no memory of it until Luke came close to duplicating the episode. I don't remember ever telling anyone, and although I must have been, I can't remember ever being in that house either before, or after that one time. By asking questions, I learned that it was not long after that the house burned to the ground, and the memory of what happened lay amidst the black timbers and waterlogged ashes, as well as buried deep in the recesses of my mind.

As the scene was played out in my mind like a giant screen television with instant replay, I felt sick with the thought of people I should have been able to trust as a child, having played such a part in the betrayal of my trust as an adult. *Was it just kid's play? Why was this done to me? Who started this mess?* I couldn't understand how it was possible not to know until so much later in my life. I did begin to understand the animosity I had always felt toward my sister. We were never close throughout my adolescent and teen years, and only became close in the most recent adult years.

What I remembered was just the beginning of a warped silhouette of me. I had unlocked the lid to Pandora's Box, and out of it came the bits and pieces of a tattered life, floating up in a mildewy mist. Over several years, more and more of my memory returned, usually triggered by a conversation with a sibling, or sometimes a dream, peculiar things I had done that started to make other things make sense. I may never be able to complete the jigsaw puzzle for the lack of one elusive piece. It was the beginning to the understanding of the reasons why that one event had led to the bizarre behavior that followed, and continued throughout my early life. Behavior that would only be viewed as *strange* to people who have a genuine knowledge of what *normal* is, because normal to me was a symmetrical perversion of innocence.

HOME SWEET HOME

If it were possible for me to relive my life from the beginning, that first moment of conception, and becoming a human being, while fitting snug and warm in my mother's womb, that could possibly be the most secure time in my life. That may very well be the *only* secure time in my life. That may very well be the one and only moment that my mother could leave her legacy to me. The only legacy she had to give, the legacy of stark naked life.

With my life there is no beginning, and seemingly, no end. I try to sort out the distorted and frayed fragments of my life, and can only come to the conclusion that it is dysfunctional, to say the least. I try to grasp on to memories while looking through a darkened mist, with blindness so desolate.

I came into this world at 6:18 am on Tuesday, May 24th, 1955, weighing 6 pounds, 12 ounces, and 20 inches long. Is grace the description for Tuesday's child? Grace is beauty or harmony of motion, form, or manner. Harmony is a state of order, none of which I've ever had. Beauty of motion brings to mind a graceful ballerina, but the movements in my life have been staggered and clumsy, resulting in many falls. I always get up; I always survive the scraps and scratches.

The children my parents produced are Mary, born in 1951, Rob

1953, John 1957, and Roger 1960. I was smack dab in the middle. That dreaded middle child, and a Gemini. More siblings would come later, with the interlinking of families.

I grew up in a wooded area just outside of the city limits of a small town in Michigan. There were about twelve houses in this area, and I lived in an old house with tarpaper siding and an outhouse that still stood in the backyard, even though we had an inside toilet. The three-bedroom, two-story house was nothing fancy with linoleum floors and plaster walls. Part of it had been a barn at one time and was slapped together with another building to form a house. I can honestly say I was raised in a barn! The city/county line ran down the middle of the house. I could stand in the living room and be in the city, and walk into the kitchen and be in the country. The house was cold and drafty in the winter and the upstairs was hot and stuffy in the summer.

Next to the house was a swampy area, with a little creek running through it that created a pond in the middle. In the summertime my brothers and I would catch frogs, pollywogs, and minnows. I loved the sound of the croaking frogs; the sensuous sound would lull me to sleep when I felt like escaping from my world. The wintertime was spent building forts and ice-skating on the pond.

Down the road was a family with three girls and a boy. My grandparents lived just across the field, and my cousin's house was two down from them. When I was ten, a large family with five boys and two girls moved in next to my grandparents. I was a tomboy, always with my brothers and the neighbor boys. After the large family moved in, it didn't take long before the summers were spent playing baseball, along with building tree forts, and fishing. The girls in the neighborhood were all older or younger than me, and I wasn't much for playing with dolls. The Christmas I was five, I got a Tonka dump truck, and my older brother got a doll. My Daddy worked hard, but still found time for his little girl, taking me rabbit hunting, fishing, and we all went for family rides in the woods, or to camp on weekends. There were picnics in the summertime with lots of aunts, uncles, and cousins. It would seem like my life was normal and happy,

but the most important thing missing was my mother. It's as if she never existed, a gnawing sense of a void that can never be filled.

I know I had a mother, but have an equivocal memory of her, most of which family members have told me. Somewhere along the line, all my memories were stolen away. Someone packed them away in a box, put them in a dark, spooky attic, and forgot about them, forgot to tell me they even existed, let alone where they were. Some memories came back to me gradually, but only ones that have left guilt-ridden scars on my lonely soul.

I don't understand the intricacies of the human brain, and how it chooses to retain some memories clearly, and pick others to block out. I don't know if I repressed what happened to my four-year-old self when it happened, or if I selectively repressed most of my childhood because of the trauma I suffered at nine years old. At nine, the blackest of my memories scarred me for life.

SCHOOL DAZED

I attended a parochial school for the first five grades, not counting kindergarten. If there ever was a hell, it was the memories I have from the inside of the immense brick building that swallowed me up every day. The nuns were the oldest and meanest the school could possibly find. Many have horror stories to tell, and mine are probably no worse than theirs. To this day, my brother John will cross the street to avoid walking past a nun.

I was a very introverted and insecure little girl. I could hardly speak to anyone without feeling totally incapacitated in doing so. I now understand that I suffered from being a silent victim. I had no friends that I can recall in that period of my life, and even now, as an adult, no one is allowed into my well-guarded space.

My family was poor in monetary standards, and I did not have the best clothes and shoes. All the uniforms I wore for school were hand-me-downs from my sister, or other girls in school who came from rich families. I would get one or two new dresses once a year. Needless to say, I was the brunt of the cruel pokes and prods of the teasing doled out by my classmates.

On the playground, I did not participate in any of the games my classmates played, not because I didn't want to, they wouldn't let me join in their fun. Many times I stood alone in the corner of a

garage door, and in the wintertime would huddle shivering, while the others were warm in new coats, hats, and mittens. My Daddy tried to do the best he could, but with a large family, I'm sure it was not always easy for him.

I felt so alone, I was always so alone. Once in awhile, I would sneak into the side door of the church and stand mesmerized by a statue of a mother holding a baby. I knew this mother was a special mother who loved all children, even me.

In the first grade I sat next to a boy who was even poorer than me. No one wanted to be near him, he had *cooties.* He looked like he never took a bath, and his hands were always filthy dirty. So, guess who got to sit next to him? Just another kid from a poor family whom no one paid much attention to— me! It seemed like they had to keep the rich and poor separated for fear of contamination.

It really didn't bother me to sit near him, somehow I knew we were sadly similar, and I felt sorry for him. I was an angry little girl, and didn't care what snotty remarks were spewed from the mouths of my classmates, so I became part of the contamination. Because I sat next to Joey, I had *cooties* too.

One day, about ten minutes before school let out for the day, I had to go to the bathroom. I knew I would never make it until the bell rang, so I raised my hand and asked if I could go. The nun would not let me because it was too close to the final bell. I could wait. I started to cry and told the nun I could not wait, I had to go really bad. As I broke out into a sweat, I knew I was going to shit in my pants.

The nun adamantly refused to let me leave, and I can distinctly remember sitting there trying to squeeze the cheeks of my ass together while I slowly shit in my pants! It seemed like all in the same moment, the bell rang and all the kids ran to the cloakroom for their jackets and lunch pails. I sat at my desk trying to stall for enough time for the other students to get their belongings and leave before I went in for mine. I knew they would be able to smell it as the disgusting aroma began to fill my own nostrils.

When the nun hissed, "Brenda, get moving!" I began to slowly walk into the cloakroom trying not to draw attention to my awkward

walk. There were still several kids in there, and Joey was in there. Being the small-contained area those old cloakrooms were everyone could smell it. Kids started plugging their noses and gagging on the putrid odor lingering in the hot rancid air. They started making fun of Joey for *pooping* his pants.

I never said a word to defend him, and I could see him looking at me, with an expression of knowledge and realization that it was me. He never said a word, and a secret bond was formed. I took my jacket, walked out of the room, into the bathroom, and emptied a large turd into the toilet before I left for home.

I decided to walk the long way home, knowing I would have to walk by the rich girl's house first. Upon seeing her I shouted, "Fuck you!" before the *rich girl* even had a chance to say anything rude to me. It felt so good, and the look of shock on Marjorie's face was so worth it. Only the boys ever said *fuck*.

The next day I got into trouble at school because Marjorie's mother called the nun and told her what I had said to her precious daughter, as if the words would corrupt her high and mighty, porcelain Miss Prissy. They had a hard time believing such a vulgarity came from my usually silent mouth. I didn't deny it, it liberated my anxiety. It was punishment enough when I had to apologize to the rich girl in front of my class. Humiliation was the norm.

In second grade we were allowed to write our names in the front of our books. I wrote my brother's name in the front of his book when I got home, and the next day I was called in to the fourth grade classroom. With the look of hollow death on her face, the nun asked, "Brenda, why did you write Rob's name in his book?" A lump of fear began swelling in my throat. I felt extremely hot, and as the tears started rolling down my face, barely above a whisper, I managed to say, "Because we write our names in our books."

For my punishment, I was told to stand in front of Rob's class, facing them, while the nun proceeded to whack my ass with a thick board with holes drilled in it. The humiliation stung worse than the board connecting on my bottom through a paper-thin uniform dress, and if that humiliation wasn't enough, I did the unthinkable. I stood

in front of about twenty boys and girls who watched as a steady stream of hot piss ran down my legs and formed a puddle at my feet. I stood there biting my lip until I could taste the salty blood and defiantly held my hysteria.

I was in third grade when President Kennedy was assassinated. I remember being sent home from school, and everyone was crying. Six months later, Mama would die and somehow in my young mind, I confused the two deaths, and the details of each day became a collage of pictures that were entwined. Later, as I tried to remember, I had a hard time distinguishing one from the other. I had confused some of the details surrounding the day Mama died. I always believed I was sent home from school when she died, but learned from my sister Mary that that wasn't the case.

I had no comprehension of death, and no one bothered trying to explain it to me. I did believe what was taught at the school, that people either went to heaven or hell, and there was somewhere in between called *purgatory*, where people waited until they were good enough for God to let into heaven. Today I have a better understanding of death, and do not believe what I was taught as a child.

After Mama's death I believed she was in heaven, and could see everything that was happening to her little girl. I would take long walks in the woods or on the beach, and talk to Mama as if she walked beside me. I always held out the hope that someday Mama would actually appear to me, and felt content with the idea that she could hear my pleas for her to come back. As I got older I thought it wouldn't have been heaven for Mama having to watch the horrible mistakes I made growing up, and the circumstances that led to those mistakes. Mama was thirty-five when she died, and I grew up thinking that I too would not live past that age. A few memories I retained were mingled with the illness that took Mama.

DEAR MAMA

Mama was always sick. She had epilepsy and suffered from grand mal seizures. Doctors didn't know then what they do today, about treating this condition. It wasn't an easy thing to control, and even with scads of prescription bottles of pills on top of the refrigerator, there wasn't much hope for Mama. The drugs were more experimental than healing, especially back in the fifties and sixties.

Mama's *spells* had begun at an early age, and continued to get worse as she grew older. In my teenage years, someone explained to me that epilepsy was usually provoked by a head injury, and was not hereditary. Even then I thought Daddy knew what caused it, but wasn't saying. That reason, I would learn as an adult. Mama was not supposed to have any more children after her first one, and with each one of us, the seizures became worse. She would go into convulsions during her labor and deliveries, and her last one was born at home.

Roger was born in the middle of the night while Rob, John, and I lay on a mattress on the floor in the next bedroom. Mary helped my aunt with the delivery because there wasn't enough time to get her to the hospital. It happened so fast, and Daddy wasn't home. I was six at the time, and remember it like yesterday. Three years later, three days after my ninth birthday, at the age of thirty-five, Mama

would die in the same bedroom where I lay listening to my baby brother take his first screaming breath.

Fleeting memories surrounding her illness remain vivid in my mind. Nowhere can I find precious remembrances of any bond with Mama. No hugs or contact of any kind, just a vacancy that explains my urgent need to feel loved. Nine years is certainly long enough to have had a mother's love, pampering, and attention. For me the void goes deep into having no sense of knowing that Mama even held me, rocked me, tied ribbons in my hair, comforted me, helped me dress, baked cookies with me, or did any of the motherly things that mean so much to people. It's as if she didn't exist for me. People speak of her as a loving person, but for me, those memories are buried in the deep darkness of Mama's grave.

I do remember being terrified one day when Mama had a seizure. John and I were the only ones home at the time, when she went crashing to the floor, stiffening and writhing in a *spell.* I knew from watching Daddy that he always put a towel in her mouth so she wouldn't bite or *swallow* her tongue. I was gripped with a paralyzing fear that would not allow me to do what I knew had to be done.

Instead, I grabbed John by the hand and dragged him into the bathroom. We hid behind the ironing board in the corner. It was so dark and cold in there, and it smelled of musty, dirty laundry. I didn't want John to know I was afraid but we were both crying, and I was trying to stay calm by telling John, "Daddy will be home soon." I was thinking that Mama was going to swallow her tongue and die, and it would be my entire fault. I don't know how long we were there before Daddy finally got home and found Mama on the floor unconscious, and John and I in the bathroom, asleep behind the ironing board. I was five at the time, and John was only three.

Another *spell* Mama had sent her falling into an old cast iron garbage burner we had in the house. Her back stuck to the side of the searing hot stove, leaving a large area with a third degree burn on her back. I didn't remember that happening until Mary told me about her having to put salve on Mama's back for her. John was younger, and he remembered it.

The old stairs in my childhood home symbolized both fear and grief for me. I remember the day Mama saw a mouse crawling on the ledge. She stood there screaming at the top of her lungs until Daddy came running to see what was wrong. Her blood-curdling scream scared the hell out of me.

I walked up those stairs one night in the pitch dark, only to have Rob jump out at me as I reached the top. In the dimness of the moon, he held up his arms and roared, while I let out a scream and nearly tumbled backward down the stairs. The dark was not my friend for a long time afterward, and I slept with a night-light for many years.

I recalled, with Mary's help, the day Daddy came down those dreadful stairs and said, "Mama's dead." He had gone to check on her because she was still in bed at ten in the morning. She was usually an early riser. It was a Saturday and everyone was already up and outside playing. That was the first time I ever saw Daddy cry, but it would not be the last.

I formed a picture in my mind of Mama lying in her bed with a distorted purple face, a tormented expression from choking on her own tongue. What a demented image to carry with me until I was old enough to look up the death certificate, which listed the cause of death as *her heart stopped.* Mama's gravestone only had the year of her death, 1964, so I also gained the revelation that she died three days after my ninth birthday. My aunt told me years later that she had been to visit Mama the weekend before, and she had looked better than she had in a long time. I was so relieved to know that Mama had actually slipped into the peaceful sleep of death without any discomfort.

The most graphic scene of Mama was when she was lying stiff and cold in a coffin. I stood there crying, looking at her, wanting her to wake up, while people were walking up behind me saying, "Doesn't she look good?" I was so angry. My Mama was lying there dead, and all anyone could say was how good she looked!

I wanted to scream, "She doesn't look good, SHE'S DEAD!"

I felt smothered when they lowered her casket into the ground and I knew Mama was not coming back up out of that hole. Mama

was gone forever, along with any trace of my personally knowing the kind of woman or mother she was. Not only was Mama underground, but all my memories were buried that day, buried deep. Years later, in counseling, I would learn that the shock of her death was such a traumatic event that I blocked out most everything from my early years. My selective memory would leave me a very lonely person, searching for Mama. There is no blacker void in a woman's life than the absence of her mother.

LIFE AFTER DEATH

A short time after Mama died I began experiencing a small pulsating form, about the size of a lemon, up in the corner of the ceiling in my bedroom. It looked like furry mold with spurs all around it. It started appearing to me at night, when I couldn't sleep. Not even the frogs croaking were solace to me. The presence was comforting and I would will it to come to me, so it could crawl into my being and lull me to sleep.

It was a gray form and even with a dim light it was always visible to me as if it were surrounded by light. I never gave it much thought until I was older and began to learn about spirits and apparitions. Then, it was a comfort and possibly Mama's way of being with me; today it might scare the hell out of me. It was up to a year that I remember falling asleep with the pulsation, feeling like it was climbing inside my head and humming me to sleep. That was Mama's lullaby.

After the funeral my aunts came in and cleaned out everything that was Mama's. They literally threw out everything that was hers. I will never understand why they did that, but Daddy dealt with things in his own way. There was never any jewelry or little keepsakes saved for my siblings and I to have when we got older. From old photos I knew she wore jewelry, but neither Mary nor I would ever

have the sentimental privilege of being able to wear Mama's wedding dress or her jewelry. I do have her wedding picture and she wore a beautiful silk gown with a long train.

It seemed like Mama never existed, but was an imaginary person who mysteriously showed up in family photographs. My grandparents blamed Daddy for her death. He had taken there youngest daughter and moved away from them when she was so young. She never should have had as many kids as she did. She was fragile, too stressed out. Their beloved daughter was gone, and in their grief, the blame lay on Daddy.

Mama's side of the family wanted to split us up and each raise one or two. Daddy refused to let anyone break up his family, and decided to manage on his own. Mary, at twelve, made the transition from little girl to little mother, and two aunts on Daddy's side took over with the cooking and laundry. Mary and Daddy did most of the cleaning, and we all had our chores. Mary got robbed of her youth, we all did. Roger, who was only three, did go to live with an aunt and uncle for six months. She could not have children and wanted desperately to keep him. Daddy said no.

I spent a couple weeks with another aunt and uncle who had a farm in Wisconsin. It was beautiful and serene, and I enjoyed the solitude, often with lonely thoughts of a Mama I missed with a breaking heart. My aunt and uncle had lots of room to run and explore. The time spent there gave me the chance to fall in love with books. They had the complete set of *Nancy Drew* and *The Hardy Boys Mystery Books*, and I escaped into a world of make believe, one filled with suspense and a false identity. I felt a constant emptiness and longed for Mama, the emptiness was worse when I finally went home.

One thing was left as a constant reminder of Mama. A print of a painting of the *Guardian Angel* scene hung on the wall in Daddy's bedroom. A little boy and girl were on a bridge. An angel stood guard over them. The little boy was leaning precariously over the edge, picking flowers. This became the one object that John and I stepped into with the magical belief that it was the two of us, with Mama

watching over us.

After I married at eighteen, Daddy agreed to give me the picture. I kept it for ten years, then gave it to John. He agreed to give it back after ten years. It was left in Kentucky at the home of his ex-mother-in-law. The sweet sentiment of Mama's wings of protection would become a loss for me too. I have searched for an exact replica for years, to no avail. I've seen many renditions of this scene, but never the same one.

NEW MOM

I have no trouble remembering my childhood after Mama's death, it's the early years that are hit and miss. One year after Mama died I would learn a secret while cleaning Daddy's car. I discovered a small bag in the glove box. It contained a charm bracelet with different shapes, colors, and sizes of polished stones. I thought it was the most beautiful thing I ever laid eyes on. I rubbed the smooth stones between my fingers, liking the silky feeling. I tucked it back where it belonged and never said a word to anyone.

Several weeks later, while bike riding along the road near our house, John and I saw a station wagon beside the road with a woman and three kids inside. They had run out of gas. I had remembered seeing this same car driving by our house several times. One of the times, the little girl in the back seat had stuck her tongue out at me, and I flipped my middle finger at her. John and I stopped to talk to this lady, and when she placed her hand on the steering wheel, there to my surprise, was the beautiful bracelet I had found in Daddy's car. Somehow I knew this woman was someone special.

Two nights later, Daddy would introduce this woman to his five children, and one year later, this woman became my new mother. I was elated, I had the one thing I needed the most, a mother. My brothers considered me a traitor when I was the first to call her *Mom*.

I think Mary was relieved at the thought of a burden lifting from her shoulders. She was able to enjoy her teenage years without having to pack lunches, cook meals, and clean house for all of us.

Our new mom had three children from a previously abusive marriage. Her ex-husband had custody of the children because she was not financially able to support them, but she could no longer take the abuse. She feared that Debi, her oldest daughter, would become the brunt of his cruelty, and her deep fear would indeed become true. The man she was married to was not Debi's biological father, and he treated her with bitterness. She was the oldest of the three and wanted to stay with her two younger siblings, to protect and care for them.

Leaving her children 300 miles away filled my new Mom with sadness, but also with hope that someday they would come to live with us. They all came to visit in the summer and when it came time for them to go back to their father, it affected all of us. There were times when we would go to camp to *hide out*, but each time the cops would have to get involved, and we would all eventually have to say our good-byes.

Debi would call often and tell Mom about the abuse from her father. He expected her to stay home all the time and watch her younger brother and sister. He yelled at her constantly and pulled her hair or slapped her. One time he kicked a chair out from under her when she stood on it to look out the window at an airplane going over.

Debi also had an uncle that had sexually molested her from the age of two until about seven. He would have her sit on his lap and under the cover of a blanket, he would fondle her. He would do this while other adults were in the same room, but they never even knew it. She feared that if she left, he would resort to doing the same thing to her younger sister. I don't know if Debi ever told Mom, but she would tell me many years later.

After spending three chaotic summers of tug-o-war, Debi came to live with us. She became my best friend and confidante. Mary graduated that year, moved away and married. She is the only one of

the original five children who has not experienced a divorce. I credit the fact of her huge responsibilities at a young age as having gifted her with whatever it takes to make something work. She remains happily married.

CHILD'S PLAY

From the age of ten to twelve I spent all my time with my brothers and the neighbor boys. I was never aware of the boys being interested in me in any way other than my being one of them. I did know that sometimes the boys went off in the woods with Diane, a younger girl. The boys talked about Diane letting them see her private parts and letting them touch her, even sticking a finger inside of her. I never thought it was a big deal, it was just something that seemed *normal*, without knowing why it was, or that it wasn't.

One of the older boys that Rob hung out with wanted me to go fishing with them one day. There was a large pond about a mile from where we lived, and we would jump a slow-moving train to get to our swimming hole and favorite fishing spot. It was nothing for me to be around when the boys went skinning dipping. On this particular day, we went out to the middle of the pond in an old wooden boat. We had been out there awhile when the older boy started rocking the boat in an attempt to scare me, which he succeeded in doing. I had almost drowned when I was eight, and was petrified of not being able to touch bottom if I was in the water.

Rob kept yelling at him to stop or we would tip over. I always looked up to Rob as my *protector.* Suddenly, out of the blue, the boy looked at Rob and said, "Fish, Umbrella, Cat, Kitten." I don't know

how I knew, maybe my sixth sense, but I knew what it meant. I could tell by the look on Rob's face that he had no idea what this code language meant. I instinctively knew I was in trouble when I took the first letter of each word and silently spelled out the word –FUCK! Having been around boys all the time and looking at adult magazines the boys stole from a neighbor, I was not completely blind to the male thought process. I knew by the leer on the boy's face what his intentions were for me. I knew it was *give or get out*, and if I didn't think of something fast, I would probably find myself drowning again.

I calmly said, "I have to go home." I was thankful when Rob couldn't figure out the code, or that he was smart enough to act stupid for my sake, and he agreed, we had to go home. After that I tried to keep my distance from the older boy, only imagining what he would do to my eleven-year-old body if he ever caught me alone.

Several weeks later I decided to sneak up to a sand pit where the boys had been digging tunnels into the side of the hill. I knew Rob was there but didn't know who was with him until I crawled into the tunnel. When I finally reached the larger cavern they had dug out, I discovered too late, the threat of the older boy was present again.

He had some ideas of his own about letting me play with them in the fort. He wouldn't let me leave until I pulled down my pants so he could see my private parts, and touch me there. Rob only looked, but I lost my confidence in him as my *protector*. I was getting claustrophobic in the tunnel and felt like I was being smothered, along with the fact that the candle they were burning was taking all the oxygen from the air. I did as I was told.

Before I was allowed to leave, I had to promise not to tell, and to come back the next day and let them do the same, or whenever they wanted me to. I promised so I could get out of my underground prison, and promised myself never to go near the older boy again. I knew he had influenced Rob to go along with his wishes to invade his little sister's innocence. I didn't know I wasn't innocent. I didn't know I had lost some of my innocence at four, and continued to lose bits of it a piece at a time, until the memories starting pounding their way into my consciousness at sixteen.

One other time after that the older boy caught me cutting through the field to go home, just before dark. It was almost like he was laying in wait for me. He grabbed me and held me up against a vacant house and started rubbing his body against mine. He said, "I'm going to fuck you." The only thing that saved me was when a neighbor came out of his house and yelled, "What are you kids doing?" I broke free and ran home.

After that I quit hanging out with the boys so much and started playing more with the younger girl, Diane. For a while we were interested in playing house, school, restaurant, and listening to records. Shortly thereafter, we made up games that involved discovering more about our bodies and acting out sexual fantasies. We had both had access to dirty magazines, and maybe it began when we started to share secrets about what the boys had done to each of us. Diane was younger, but she brought up the idea, and was more the aggressor, which is atypical. I learned that Diane had actually had intercourse with my brother John, and some of the older boys, and was even being pursued by an older man who lived in the neighborhood. Diane was only ten, but she was much more schooled than I was at twelve.

We followed the subconscious pattern that was in both our backgrounds, playing *doctor*. We made up the *sleeping game*, with me pretending to be asleep and an intruder comes into the bedroom, takes my panties down and starts to fondle me until I wake up and become submissive to him. Diane knew what she was doing and I would become aroused when her finger would touch my clitoris or she would slowly insert it into my vagina. Back then I didn't even know the technical names for my body parts. All of the tingling sensations were new to me, and I enjoyed it.

Madra was a code name for another game we played. I would pretend to be a little girl, and Diane was a man who would entice me into a shed and threaten to kill my parents if I did not do what he said, which was to pull down my panties and fondle me. The *man* always made me promise not to tell.

When we played *doctor*, Diane used all kinds of gadgets to poke

and prod me with, always examining my genitals, inside and out. Bobby pins were used to clip onto my clitoris or to secure my outer labia so she could get a better view of my inner labia. She inserted Popsicle sticks or plastic lids from fingernail polish bottles, just to name a few of the *surgical instruments* that were used. The thought of touching another girl always repulsed me, but I enjoyed being touched, and Diane mutually enjoyed her role of touching.

If all of this sounds outrageous to you, it is even more outrageous to me now that my childhood is behind me, or at least pushed to the back of my mind. These games were played in the woods, at one of the boys' shacks when they weren't around, in a camper trailer, an old barn, and finally in our respective bedrooms, and eventually included Diane's younger sister. All three of us swore to secrecy and promised not to tell.

Everything we did together incorporated some kind of sexual game into our everyday play. It all seemed so *normal* that none of us questioned that what we were doing was so terribly wrong, but we all knew we could not get caught at our games, especially by the boys.

It all ended the summer I turned fourteen and started to experience a more intense desire whenever Diane would touch my clitoris or insert her finger inside me. I didn't know what an orgasm was, but now know that was what I was experiencing. It ended the day Diane expressed the desire to suck my nipples the way we had both read about in the dirty paperbacks we had shared with the boys. That, along with the image of desire on the women's faces in the dirty magazines with explicit pictures, was enough to make me realize that being with another girl was becoming a sexually arousing familiarity, it was no longer a game. I think I naturally found a woman's body attractive because of all the magazines we looked at. I didn't know what lesbianism was, or that some women preferred other women to men. At such a young age, I was neither wise nor learned. I was experimenting but naïve. I never had the "birds and the bees" talk that most girls might have with their mother.

The closest I came to the "talk," was when Mom told me about

girls reaching a certain age and bleeding. I don't even think she used the word "menstruation." This came after Mary came home one day to find her tampons strewn all over the front yard. John and I were pulling the strings out of the cardboard inserts and throwing them out an upstairs window. We were using them for hand-grenades. Mary may recall this as her most embarrassing moment; we were just two kids having fun!

Shortly after the games ended, I learned that Diane had broken her promise and revealed our secret to two of her friends, which when I was confronted with it, I adamantly denied. None of us mentioned anything about it again and even now, as adults, there is still an awkward self-consciousness in the room whenever any of us are together.

Sadly, Diane and I both became very promiscuous and to add to the torture and guilt of childhood, Diane is an alcoholic. I doubt if I will ever fully comprehend my adolescent years, but know the impact it had on me in years to come. The self-destruction so powerful I wished myself dead, often enough to be afraid of my own thoughts.

SPARE THE ROD

Daddy grew up in the days of the dreaded woodshed, and it carried over into the way he disciplined his own children. We were never instructed to go pick a willow switch when discipline was meted out. Instead, we were instructed to pick a board off the woodpile. There was no padding our behinds with tissue paper or a book; it was *pull down your pants*.

Rob always got it the worst, maybe because he was the oldest boy and was expected to set an example for the rest of us. I remember some of the whippings he got, either in the woodshed or just out behind the house. Some of them, all the siblings had to be witness to. When Rob was twelve, he got into trouble for being with a friend who stole some fishing tackle. The boy was smart enough to have Rob put the stuff in his pocket incase they got caught, which they did.

Rob was brought home in a police car and the punishment began after the cops left the house. We all had to watch so we would know what would happen if we ever decided to try the same thing. It didn't make any difference that Rob did not actually steal the stuff, he was an accomplice. With his pants down around his ankles, Daddy spanked his ass until the one-inch thick board broke in two. We all watched in horror, crying because we thought Rob was going to die.

He had welts and bruises that took weeks to heal.

There were other times Rob was punished in this way, but this is the one time that sticks out freshest in my mind. He was always into something. He blew up a mailbox with an M-80 firecracker, or got into fights at school, with the same results. In this day, Daddy would be in court for child abuse, then, it was discipline. Rob swears today that it is what made him a man. I know it is what hardened his heart.

My brother John was the family clown. He was smart but never wanted anyone to know it. He wouldn't pay attention at school or would screw around and not do his work. He spent some time in the woodshed too. He had his spot on the stairs landing with an old school desk facing the wall. If he didn't do well in school the nuns would call Daddy, and he would have to sit in the desk for hours and just stare at the wall, refusing to do his homework.

I got one whipping from Daddy when I was eleven years old. Mary and I would take turns doing the dishes, keeping track on a calendar by the week. One night Mary didn't do her dishes. The next day was my turn, but I thought Mary should have to do her share first. We argued and Daddy hollered at me to just do the dishes. Afterwards, I wrote FUCK YOU on Mary's pillowcase with a pencil. It was real faint, but of course she noticed and told Daddy.

Mom asked each of us who did it; of course everyone denied it, including me. She decided to make all of us write the words on a piece of paper to compare the printing. Everyone took their turn printing out the words, right down to Roger who could barely write or spell. When it came my turn, I tried to disguise my printing by making the letters differently and slanting to the left, instead of the right. Mom didn't have to be a genius to figure out who it was.

Daddy took me in the bathroom just before suppertime. He had a piece of kindling about a half inch thick. Of course, I had to drop my pants to my ankles. He grabbed my arm and started whacking away and I tried to protect the delicate cheeks of my butt by covering them with my hand. That didn't stop Daddy! I danced around and screamed and cried, "I hate you, I hate you." After what seemed like an eternity, Daddy stopped and told me to pull up my pants, and come out when

I stopped crying.

I composed myself and went to the dinner table. The only place left to sit was next to Mary. When I sat down, Daddy told me I had to apologize to Mary. I refused and promptly took another trip to the bathroom. After a few more whacks, I came out, still refusing to apologize, and was sent to bed with no supper. That was the one and only spanking Daddy ever gave me and he always told me it hurt him worse than it did me. I think it did.

PURSUIT

He was always there, this older man who would stop to tease and bullshit with the neighbor kids. He was handsome with dark hair, black eyes, and a strong muscular build. I may have been infatuated with him, but it wasn't evident. At first he was just like a big brother and would take me fishing with him and the boys. He would stop sometimes and play baseball with us in an open field in the center of the neighborhood. He always stopped to talk when he was coming through on a shortcut to town. He was always there, and I found myself looking forward to seeing his truck coming down the road.

I don't know when it first became evident that Joe was interested in me in a sexual way, it must have been when I started budding into a young lady, and not just "one of the boys." It started innocently enough by him making comments about how I was starting to change and look like I wanted to be touched. I took it all in stride and thought he was teasing me, Joe was always joking around.

Every time I was doing something with the boys, Joe would show up. He had the boys help him tear down an old house and I was the official water boy, hauling jugs of water from an old pump. He started making comments like, "When are you going to let me pop your cherry?" Of course I knew what that meant, thanks to the boys and Diane. Joe would say, "Let me be the first for you, don't let one of

these boys get you, they don't know what they're doing, let a real man show you what it's all about." I thought it was all in fun and just enjoyed the attention, but secretly wished for it to be true.

As my body began to go through changes, I was showing the potential for generous curves, and Joe's attention grew more and more serious, until I realized he WAS serious. He wanted to teach me about sex and I would fantasize about "doing it" with him. During this time I learned from Diane that she had had sex with Joe when she was eleven, so why shouldn't I at fourteen? I know now that he would have been considered a child molester. His was a subtle and persistent attempt to win my trust and gain my virginity.

As time went by and I became more frustrated with my own sexuality, especially after all the feelings provoked by the games with Diane, I began to plan in my mind the right opportunity to give in to Joe's asking to "pop my cherry." It was no longer a joke, I was head-over-heels for this tall, dark, and handsome older man, and I wanted to learn everything he could teach me.

After a year, the opportunity came when I was baby-sitting for his son. One night for some reason, he came home before his wife, and I knew there was a tension between us. I had to wait for his wife to come home before I could get a ride home. I caught Joe looking at me a couple times and knew our thoughts were both running in the same direction. Nothing happened. Instead, Joe retreated into the kitchen, sitting at the table looking at a girlie magazine until his wife got home and drove me home.

A few weeks later I was walking down the road just before dark when Joe came by in his truck. He saw me and stopped to talk, just as he always did. I finally got up the courage when he kept asking me to go for a ride with him. I trusted him, after all, I was used to being around him, but I also knew everything had changed between us. It was an unspoken awareness of each other that had taken us both over the line. It was no longer a guy and a kid sister, we were a man and a girl who wanted to be a woman, and we both knew what was about to happen.

I finally said the one word he wanted to hear, "Yes." I wanted Joe

to be my first. We started to ride slowly down the road when Joe's brother drove down the road toward us. He recognized Joe's truck and stopped to talk. Joe kept driving slowly away and his brother started to back up to catch him. Finally Joe stopped and when the two trucks were side-by-side, his brother realized I was in the truck and asked Joe, "What in the hell is going on?"

Joe laughed nervously and said, "Nothing, there's nothing you need to know about." That bit of hesitation caused me to change my mind.

After Joe's brother drove away, I told Joe it was getting late and I had to go home. He tried talking me into staying and coming for a ride to someplace secluded, but I insisted I had changed my mind, and Joe honored my wishes. He wasn't a rapist. I promised not to tell.

The occasion never arose again and Joe didn't pursue the chance as often. I was six months shy of being sixteen and wanting to date, and was taking notice not only of boys my age, but men who were at least ten years older than me. I knew one of them would eventually be the one to ordain me into the world of sexual desire and wanton pleasures of being loved by a man.

I never thought of Joe as a child molester until much later, when all the talk shows were getting into that subject, and adults were coming forward to finally tell their stories of being molested as children. Many people were on these shows, breaking the same promises that I now choose to do, at the expense of having people wonder what kind of person I really am. Bearing ones' soul is not an easy decision to make, but I feel a good one. Even though Joe had never touched me, he had shadowed me and would have had me, if I hadn't changed my mind. He never molested me, but would have triumphantly taken my virginity when I was fifteen and he was thirty-five.

POPPING THE CHERRY

When I was eleven, I got naked with a neighbor boy and he got on top of me and rubbed his little penis between my legs. He thought he *got my cherry*, I wasn't quite sure what we had done, only knew it was a childish attempt to replicate what we had seen in magazines. I knew the woman was supposed to experience pain and bleeding, so I knew I hadn't experienced the *real thing*.

Regrettably, I lost my virginity on my sixteenth birthday. A twenty-seven year old man was the captor of my half-hearted innocence. Innocent in the sense that I had never had a penis inside me, but not so innocent in the sense of knowing the joys of masturbation, and experimenting with both boys and girls. I was the essence of dissatisfaction.

I met Frank when I was walking to a party store on my lunch break from school. He was perched atop a telephone pole working on the lines. When I walked by he whistled and said, "Hi pretty girl!" What a line. I looked up at a tanned and burly man with a smile on his face that won me over on the spot. He had a southern drawl that was even more exciting than how he looked in his tight jeans from my point of view.

As I stood on the ground licking my fudgsicle, Frank asked where I was going. I told him I was on my lunch break from school, and

when he asked if I'd come back the next day, I said, "I go to the store everyday at noon; I'll stop and talk to you." I noticed his eyes were an intense blue that reflected the sky. I couldn't believe he was actually interested in me. As wise as I seemed, my naïveté was delicate, and so it began – the summer romance that would have my head spinning for five months.

Although I kept it a secret from Daddy and Mom for a while, I saw Frank every chance I got. We spent time walking the beach, picnicking, going to the drive-in movies, to a tavern to shoot pool, or just riding in his hot red GTO. I felt like a prom queen and was the envy of the girls I never associated with at school. They would see me get dropped off at school after lunch, and I imagined them green with envy.

When Daddy and Mom finally met him and found out how old he was, they kept close tabs on me, not giving an inch with my eleven o'clock curfew on weekends. Frank never put any pressure on me to have sex; he knew I was a virgin. He was taking the time to woo me. I was looking for someone to give my heart to. He was looking for a heart to break. He made promises and I thought he was my knight in shining armor, come to rescue the princess of doom. Little did I know, my heart would become ceramic and be smashed on the floor in a million pieces.

As it is the dream of all small town girls, I wanted desperately to leave it some day, and Frank was my ticket out. He talked of leaving at the end of summer for his next job, and we made plans for me to go with him when he was settled into a place. He would look after me and I could continue going to school. If my parents didn't agree, which they wouldn't dream of, I would run away! Stupid me, I believed the dream, not once imagining my whole life would soon seem shattered.

There were heated moments in his car, the windows steaming up with our heavy breathing, our hearts racing as we drove each other to the brink of orgasm. I had never heard the word *orgasm*, didn't know what one was! There was tremendous foreplay, but no sex, not until I was ready, and Frank was extremely patient.

I would soon be sixteen and when I finally agreed, we made plans to "do it" on my birthday. I knew it was going to happen this time, I was ready. I didn't even tell my stepsister Debi, and we shared everything. Women weren't allowed in the rooms at the hotel where he was staying. I would have to sneak up the stairs, knowing I would enter the room as a girl and indeed leave as a woman. It would be a turning point in my life. I would no longer be a little girl; I would be a woman, Frank's woman. His nickname for me was "Little Princess," and that is exactly how I felt as I went to his room to seal the promises Frank had made me.

I will never forget how my first time was. With all the anticipation and heated foreplay on the many nights previous, I thought it would be the most divine encounter I could have. Instead, there was no intimacy and no foreplay. We took off our clothes, got into his small bed, in his small room, he got on top of me, put his small, semi-hard penis inside me, took three strokes, got his rocks off, and it was over before I could have counted sixteen candles on my birthday cake. I had no pain, no bleeding. I didn't know what a hymen was, I didn't know that at the age of twelve when I fell on the crossbar of a boy's bicycle, that I had actually popped my own cherry! I just thought, *Is this all there is?* I no longer felt loved or even a little special – just dirty and cheap, and used.

I continued seeing Frank but we only "did it" that one time, the notch on his belt. I still wanted to leave with him, just to get away from small town life. At the end of summer, Frank told me he had to leave the following week. He promised to send his address and later send for his "Little Princess." "Maggie May" was the last song we heard together and how fitting it was. Summer was over and it was back to school for me. I wrote a page in a letter every day waiting for an address to send it to. I received one letter with no return address (peace offering for his guilt?) and still I clung to the dream of Frank coming back for me. After as many days, I tore up the fifty-three page letter that was never meant to be sent.

I felt desolately alone and tried to cut my wrists with a razor. No one ever knew. My attempt failed when the only razor I could find

was a dull rusty one. I couldn't even get my wrist to bleed, only produced scratches. If I were to lay eyes on Frank even today, I would gladly thank him by spitting in his face, after I slapped it.

He will always be remembered as the man who stole my maiden head and started me on the road to promiscuity and distrust for men, and there would be many. I began a delusional search for sexual desire that would take me to the depths of my being. I began to search for myself and was never satisfied with who I was, always searching, deprived of love, and expecting to find it in sex.

WILD CHILD

I was no longer "Daddy's little girl," and I began to hang out more with Debi. She had her own friends and always had guys interested in her. I went to a few parties or on booze cruises with her and another girl. I would go out with guys from out of town; none of the local boys were interested in me because they didn't think I "put out." When I did, no one ever knew because the guys would leave and I'd never see them again. I was safe from getting a reputation; the local boys couldn't share stories about me.

I would meet guys while riding or walking around town at night or if we went camping at a favorite campground. I didn't have sex with all of them, some I just fooled around with. I never used any type of precaution. I didn't know the actual facts of life so I wasn't exactly sure all the factors in a woman becoming pregnant. Back then only the older boys were smart enough to use condoms. Dad started calling me a tramp whenever I would come in the house late at night. I decided it didn't matter if I did or didn't have sex; he was going to call me that anyway.

I went cruising with one guy in early winter and we ended up going parking. We never had sex, just more fooling around. We both fell asleep and had left the lights on and when we woke up freezing at 4 o'clock in the morning, discovered the car battery was dead.

Instead of walking into town we huddled together under a coat and went back to sleep. At around 8 o'clock a guy came along and jump-started the car. I knew I was going to be in deep shit when I got home. Dad would never believe what had really happened so I walked in the house to face him. All I said was, "I won't even tell you, 'cause you won't believe me anyway!" I was right; he just called me a tramp and walked out of the house.

I put myself in many compromising situations that could have been disastrous for me. I got on a motorcycle one night with a perfect stranger. We took a ride outside of town. Stopping along the road, I let him kiss me, then we went out to where he was camping, which was about twenty-five miles up into the woods. There were two of his buddies there and I ended up spending half the night around the campfire, them smoking pot and drinking. I never drank much because I hated the taste of beer, so I always had my wits about me, as slim as they were. I slept in a tent with Zeke but we did not have sex, he never touched me. The next day he drove me into town, dropped me off, and I walked home. I left myself so vulnerable to chances of being raped it was unbelievable that it never happened.

The first time I smoked pot was with Debi, Kevin (the same one that molested me at four), and his friend. We had been on a booze cruise and were sitting out in front of the house. We had a curfew of 11 o'clock so we figured we were okay if we sat in the car in front of the house. It was October so the nights were getting colder and Mom was in the hospital, she had just had a baby the day before, her second one with Dad.

When we tried the door to the house, it was locked! Dad had locked the door because he thought we missed our curfew. We ended up sleeping outside all night, under a thick felt blanket used to cover the woodpile. We froze our asses off! Early in the morning we decided to get into the car and sleep. Dad came out to go to work and started shaking and rocking the car back and forth and woke us up. He was pissed! He told us we were both kicked out of the house. We ended up going up to the hospital crying to Mom and she soothed things over for us. Dad never did believe we were home by our curfew and

found the door locked. We never believed him when he told us he never locked the door. One logical explanation – the door latch froze.

Once we had experienced marijuana, we made it part of our weekend scene. We would party with guys from Detroit who had a cabin by my uncles. Dad knew these guys also, so he never said too much when we were with them. We'd usually spend the night at their cabin and it was okay. I started having sex with one of them and they introduced us to some kick-ass pot, nothing like the homegrown we were used to. So for about five weekends out of the year, we got really wasted with those guys. It was the only time I ever listened to *Jethro Tull.*

One Friday night my aunt dropped Debi and I off downtown. We ran into these guys later and went to their cabin to party. No one knew we were with them and there was no telephone to call home. We didn't get home until 2 o'clock the next afternoon. By then it was too late, Mom and Dad had already called out the *posse.* The state police had been notified and were out looking for us. All anyone knew was that my aunt had dropped us off at 9 o'clock the night before and no one had seen us after that. Dad never punished Debi; I guess he thought it wasn't his place to do it. Of course, the tramp got grounded for two weeks. Debi got so mad, she yelled at Dad to punish her too! He wouldn't do it. She ended up sharing my punishment by staying home for the two weeks I was grounded to prove a point and show her loyalty to me.

Somewhere during this time was when I went out with Luke and had the repressed memory unravel from the recesses of my mind. It was then that I realized it was Kevin who had violated me so many years before. I never felt quite the same way about him after that but never said anything to him. There were times he was partying with us that I wanted to confront him but didn't. By this time he had gone over to Vietnam, came home, and married; what would be the point? I accepted the fact that he had been no more than a child himself.

Dad made his own wine, beer, and moonshine. At times there was a homemade still on the kitchen stove. One weekend Debi and I got into the shine. We drank about a half gallon of the stuff, pure

alcohol, the kind that burns an invisible flame, about 110 proof. We drank shots all day and never got drunk. No one ever believed this story so I honestly won't be offended if you don't believe it either. That night we went to Gramps' hunting shack with Kevin, his brother, and some of their friends. We went to camp often and spent the night there. We were telling them about all the moonshine we had drunk during the day. Of course they laughed and told us we were full of bullshit.

We had a small bottle at camp so they poured me a shot mixed with 50-50 sour mix. I drank it down and felt my insides contorting. I knew I was turning green at the gills. I went outside and puked until I thought I would die. By rights, I should have died. I probably had such a bad case of alcohol poisoning that if I had fallen asleep they would have been burying me.

When we got home the next day, all the guys came in to see Dad and were telling him the bullshit story we had told them about drinking his moonshine. He went and got the jug, one of those old gallon vinegar bottles, and sure as shit, it was half-gone! They still didn't want to admit they believed us, they kept telling us that we dumped it out.

I started going out with Brad, my cousin's friend, when I was seventeen. I thought I had found true love. We were together for about a year and he gave me an engagement ring for my birthday. I would graduate in a month and we were going to wait a year and get married. Brad was special but I still had a wild side to me and I was a big flirt. By then Mom had found out I was having sex so she got me on birth control pills. I wouldn't have to worry about unprotected sex anymore.

Brad worked out of town so he wasn't home too often but I never went out on him, just flirted. During a flirtatious moment a guy noticed my engagement ring and asked if I was engaged. When I told him I was, he said, "That's too bad."

I said, "I know!" Those two abrupt words from my own mouth convinced me that at eighteen, I was too young and not ready to be married and settle down. I got to the point of thinking a man really

loved me, and then I bolted. I broke our engagement but not until after Brad had purchased a doublewide trailer. It took him a long time to get over that and I don't think he ever forgave me. He would surface again in my life at a very dark time, with a near fatal result.

I don't know why but I went off the pill. I guess I didn't want Mom to think I would be having sex with anyone. Brad came to the house several times, trying to talk to me, but I refused to see him. Dad was so disgusted with me. He really liked Brad and wanted me to marry him. He is still a good friend of Dad's.

After I graduated I still lived at home and started working at a bar in town. I liked what I did and was content not having a steady boyfriend. I could flirt, and pick and choose who I wanted to see, and pick and choose if I wanted to have sex with any of them. Debi worked at another bar on the other side of town and lived in the upstairs apartment. Sometimes I would stay with her on weekends.

One Saturday night, she was gone on a date and I walked to her apartment after work. Her father was visiting her so he was staying there. When I walked in, he was in the bedroom he used, so I curled up on the couch. I was almost asleep when I heard his footsteps softly coming out of the bedroom. I thought he was going to the kitchen for something. He stopped by the couch and squatted down by me. He started taking the blanket away from my body. I thought he was cold and figured I'd just let him take it. To my horror he started rubbing his hand on my body, to my breast. I flung my arm out to knock his hand away and hollered, "Get your fucking hands off me!"

He said, "Just let me touch you." I jumped up and was going to leave, thinking to myself, *What if he rapes me?*

He said, "I'll leave you alone, don't tell Debi." He went back into the bedroom and shut the door. I sat on the couch shocked at what he'd just done. What was it about me that said "Molest me, take advantage of me?" Debi came in a while later and we sat up and talked about her date. I never told her what her father had done, it would have hurt her more than it did me, and I loved her enough not to cause her any pain.

Debi and I decided to rent a trailer together and it felt good to move out of my family home. I was becoming more independent, or so I thought. I didn't have a car so I walked back and forth to work, which was only five blocks. I could usually catch a ride if someone saw me walking.

I was sitting in the bar where Debi worked one night and started talking to a guy who worked down the road from my family home. He used to see me walking when I still lived at home. He always waved or whistled at me as he went by. He knew I had been with Brad for a year and I guess he wanted a sample. I went on a booze cruise with him and we ended up having sex at his house. It reminded me of my first time. With a semi-hard dick he barely got his rocks off. We only had sex one time, and with no protection, it was enough to nearly ruin my life.

Three months later my breasts were swollen and tender, I had missed two periods, and I was sure I was pregnant. Back then there were no home pregnancy tests. If I wanted to be completely sure, I would have to go see a doctor, which I wouldn't dream of doing. I decided then and there to kill myself. At 1 o'clock in the morning I walked down to a bridge and was going to jump. A river flowed under it and at certain times of the year it was real shallow, and there were huge rocks in the water. I knew if I jumped out far enough that I would land on the rocks below and if I was lucky, I would be smashed to smithereens.

I didn't feel like I could confide in anyone or deal with this predicament. When I got to the bridge I decided to smoke a cigarette and realized I didn't have a lighter or matches. *Damn!* I then decided to walk down under the bridge to make sure the water was low enough to expose the huge boulders. I started down the incline and in the faint light of a streetlight I saw a woman sitting on the ground. Startled, I said, "What are you doing here?"

She said, "I'm waiting for someone." *At 1 o'clock in the morning?* I stood there and talked to her for maybe five minutes, I don't remember what we even talked about. By then I decided I really wanted that cigarette, and decided to walk down to the bar where I

worked, and get matches. I turned and started to walk away and turned back around to say something, and she was gone, vanished into thin air! Had she been waiting there for me?

I honestly believe an angel intervened in my suicidal plan, an angel in the form of a woman "waiting for someone." There is no doubt in my mind that I was not meant to commit suicide. I walked to the bar, got matches, went home, and the very next day when I went to the bathroom, I was bleeding and happily thought I had started my period and that I wasn't pregnant after all. I also passed a large blood clot the size of a small fetus, with very severe cramping. I was too stupid to figure out that I had miscarried. I believed for many years that I had just started my period. Now I know differently.

Six months later, I met the man who would become my first husband. I knew I didn't love him, but I desperately wanted a baby. I think subconsciously I was trying to replace the baby I had unknowingly flushed down the toilet. Even if I could not love a man, I knew I could love a baby.

PANDORA'S BOX

According to Greek mythology Zeus sent Pandora to earth as the first mortal woman. She was fashioned to punish men who had offended him. Zeus made her an evil to men with the power to do evil. She brought with her a pithos (vase) filled with curse, strife, pain, death, sickness, and all other afflictions. She was instructed by Zeus to not open the vase, but Zeus knew she would be too curious to resist it. As a final gesture of cruelty he enclosed hope, to prevent humans from taking their own lives in despair and escaping his wrath.

Pandora, her name meaning *all giving*, opened the vase and all the evils of the Earth were released on all of mankind, but the hope was also released. During the medieval period, Erasmus mistakenly translated pithos for pyxis, and thus Pandora's vase became Pandora's Box. The expression "Pandora's Box" is for something that appears innocent but is actually capable of unleashing unknown evils.

When my Pandora's Box of memories was opened and all the evils of my early years were released, what I had thought was an innocent childhood, became the creation point of my personal lifeline filled with strife, pain, sickness, death, afflictions, and the curse of being born under a lone, ominous star. Along with it, hope was released; hope that someday I will be able to sever the festering blister of my conscience.

When my memories came flitting back one by one over a period of several years, I was disgusted with the sickness of my guilt for my outlandish behavior. At the same time, I came to the understanding that it all began in the closet with Kevin, and I have a justifiable explanation for why I behaved the way I did. I also realized that my fear of being alone and unloved was the factor in my choices of men in relationships. I let my fear of being alone blind me to the fact that I was never truly loved. From one abusive relationship to another, I was attached with an unseen umbilical cord that was missing from my birth. A fetus cannot survive without an umbilical cord, and I could not survive unless I was fed with the feces of someone's abuse, disguised as love.

After the pictures of Kevin's violation slammed into my head, others followed, simulating the progression of a slide show:

CLICK- Me, probably five years old, my brother John, three years old, upstairs in one of the bedrooms, under the bed, my panties down, John putting ice cubes on my private parts, Mama catching us in the act, making us come out from under the bed, pulling up my panties and saying, "You can't do that." We were sent outside to play.

CLICK- Me, five years old, my brother Rob, seven years old, playing in Mama and Daddy's bedroom, me naked, pretending to be a mermaid that he finds. I'm in the drawer of an old mirrored vanity. He carries me to the bed and touches my private parts. Mama finds us and says, "You can't do that."

CLICK- Me, six years old, a neighbor boy, also six, playing in a sandpit, taking off all our clothes and jumping off the sand hills, two older boys catch us, send my friend home and make me stay, so they can touch me.

CLICK- Me, eight years old, Rob, ten years old, playing in my bedroom, me naked under the covers, pretending to be asleep, Rob sneaking in to touch me, Mama coming up the stairs, Rob hiding in the closet, Mama telling me to come and do the dishes. *I can't get up, I'm naked.* Mama's trying to pull the blankets off me. Me - yelling at her to go away. *Did she know I was naked? Did she know what we were doing?* With her face of mixed emotions, she leaves and goes

downstairs. I get dressed and follow.

CLICK- Me, eight years old, playing up on the sand hill, letting a younger neighbor boy see my private parts, him putting tiny twigs in the soft folds of skin, nearly getting caught by the older boys, hurriedly pulling up my pants and walking home with the twigs still there and irritating my skin.

CLICK, CLICK, CLICK. I wish I could click it all away, my kaleidoscope of shame and embarrassment. Sometimes I think it started with Kevin, other times I think it began earlier, possibly as a baby, and there is always the blurred face of an unknown molester that never comes into focus, but slithers through the black hole in my mind. *Is that face attached to a person? Why the sleeping game?* Repeated perhaps because of a subconscious violation on a sleeping baby girl, awakened to the fondling of an unattached hand? *Did someone touch me before I was four, before Kevin?*

I have flirted with the idea of hypnosis but am afraid of the surrender of my mind into a zone where it floats freely until it is captured. Enough pain comes with the opening of Pandora's Box; would I be able to live with the memories found within the lining of that box? I may never know what is still locked inside the little girl locked inside of me.

CLAUSTROPHOBIA

I didn't know I suffered from claustrophobia until I was eleven years old, when I was dragged kicking and screaming by some older boys in the neighborhood. They had a German shepherd dog and her domain was a very large doghouse in the back yard. The dog was out running around, not tied to the house. They thought it would be funny to put me inside the doghouse. One held a board over the hole and the others got on top of the doghouse, banging on the roof and laughing at me.

I couldn't breath and my lungs felt like they were being scraped with a serrated knife. I was in a panic mode, my drool tasting of blood. The panic swept over me like a death sentence. I didn't think they would let me out, *I was going to die.* It was an innocent childish prank; they had no idea of my overwhelming fear. I begged and pleaded with them to let me out, kicking on the board over the hole, to no avail. When I was convinced I was going to die, a surge of energy gave me the strength to push up on the doghouse and push it over, sending the boys sprawling in all directions. A death wish was on my teary face as I emerged with the intentions of killing the first boy I could grab. They all went running off when I grabbed one of them, pushed him to the ground, and swore I'd kill him.

The next episode happened when we were playing hide-and-seek.

The best place to hide was under an overturned wooden boat. Being skinny, I could crawl under the side where it didn't quite touch the ground. *I was okay.* When all were found, except me, the boys all sat on the boat and decided to wait until I got tired of hiding, not knowing I was their captive under the boat. When I yelled at them to get off the boat and let me out, it wasn't soon enough for me. I rolled over unto my stomach, pushed up on the boat with my back, and sent them sprawling again, overturning the boat. They were shocked that I had the strength of ten men, and then they remembered the doghouse.

After that, they were leery of this bionic strength I seemed to possess. I realized I could not handle being in closed places. This was before the memory of the closet but now I know where it originated. It wasn't as much the fear of being in a closed area, more the thought of not being able to move, or get out. I would go into the same kind of panic mode when the boys held me down and tickled me. I finally learned to control the uncomfortable feeling of being tickled, pretending I was not ticklish until they gave it up. This fear of being held down or trapped would surface later in my life when I would reveal this fear to a man who would use it against me.

RED FLAGS

I met Carl when I was still in the trailer with Debi. I was walking home from work when he drove by a couple times and let out a whistle. He was a construction worker, and it was a wolf whistle. The next time around he asked me if I wanted a ride. I didn't know who he was but I knew he was a local guy. He gave me a ride home and asked if I wanted to go to a high school football game. I had never been to a game, so I accepted.

I didn't know the first thing about football but he was gracious enough to explain the game to me. I had fun and we started seeing each other. I told him I worked at the bar so he started coming in after work. We'd go for cruises after I got off work or go to the movies on my day off. He started introducing me to his friends and we would go to their houses to play cards. It made me feel good when they all accepted me into their group. He was ten years older than me and all his friends were married, some with children. We went to a New Year's Eve party at one of his friends' house and I was so embarrassed when they started to watch a porno movie. I was still a little naïve and had never seen anything so revealing. I felt really uncomfortable and finally went into the living room with two other women who didn't want to watch either.

We had only been seeing each other for a couple months when he

asked me to move in with him. It was almost wintertime and getting colder in the trailer I shared with Debi. She was going to move back to Dad's so I thought, *why not?* I didn't know he lived with his mother until I moved all my stuff to his house. I was a little floored, but his mother was really a nice lady and she loved having me there. It didn't take long for me to see that Carl treated his mother terribly. I hated the way he treated her. Yelling at her, always yelling, he never spoke to her in a normal voice. His mother told me Carl's father was the same way. He was very mean to her. He had died when Carl and his sister were really young. I learned fast that Carl did not have any respect for women, and soon, that would include me. That was the first red flag and I should have made a run for it but didn't.

I found out Carl had been married and had a five-year-old daughter. I loved kids and encouraged him to start getting her on weekends so we could be a family. I loved that little girl. When he brought her in the bar to see me at work, his ex-wife found out and started giving him problems about his child-support. He was way behind. He couldn't pay what he owed so he decided to let her new husband adopt her. She dropped all the child-support he owed, and I lost my ready-made family.

I wanted a baby so bad so we decided to get married and I quit my job at the bar. I went off the pill and three months later found out I was pregnant, we had been married a month. Dad never really approved of Carl, he always said he had a big mouth and he still hadn't forgiven me for jilting Brad. No one would be good enough in his eyes, except for Brad. Dad came to the wedding but only for the sake of appearance.

I gave birth to my son in November of 1974. He was one month premature and everyone gathered at the hospital because he was not expected to live. In the eighth month of pregnancy the valve to a baby's heart closes, and reopens in the ninth, so he was at high risk. The valve was not developed properly. During the delivery my cervix clamped down on my baby's head and they used forceps to deliver him. They used ether to knock me out and I almost overdosed on it. I only weighed 120 pounds and when I started to hyperventilate,

they slapped the mask over my face. I thought it was oxygen and was reefing on it hard, taking in too much. My son was in sad shape, only weighing a little over four pounds. In 1974 only miracles kept premature babies alive when you lived in a small town. They didn't have the advantage of equipment and experts that bigger hospitals do. They kept me knocked out and by the third day, gave him a 50% chance of survival.

I never bonded with my son the way new mothers should. He was in the hospital for three weeks and the only contact he had was the nursing staff. I stood in the nursery window three times a day and watched someone else nurture my son. It was the most difficult thing I had to do. The pain of empty arms was even more enhanced when I had to leave and go home without him.

When he was five pounds we were allowed to take Randy home. I gave all my love and attention to my son. Carl drank. I never thought he drank as much until after we were married and had the baby. He bowled on a league two nights a week and would come home hammered, with nothing good to say to me. He would call me a slut, whore, bitch, cunt, and attached fucking to the beginning of every cutting word.

I thought things would improve for us if we had our own home, so we bought a small two-bedroom house and moved out of his mother's. She was probably happy to be rid of him, but she hated to see me and Randy go. For me, it was never a matter of love; it was more a fear of being alone and wanting a family. Some will say, "She made her bed, let her lay in it." I did lay in it, for five years, and it nearly killed me.

Life was okay for a while with the excitement of having our own home and fixing it up. The drinking continued and got worse with time. Carl would come in drunk and pass out, waking in the night having to go to the bathroom, and not knowing where he would end up to do it. He would piss in a clothes basket or on the floor, unless I woke up to guide and push him to the toilet. I was always so afraid he would piss in Randy's bassinet. I felt more like a nurse or a babysitter with Carl.

His chosen words of endearment never changed. I was still a fucking slut, whore, bitch, and cunt. He would threaten to hit me, but never did. I left him a couple times and stayed with Mom and Dad for a week or two at a time. I threatened to divorce him if he didn't quit his drinking and he would quit long enough to get me to come back. I was on a seesaw of emotions, up and down, up and down. The motion made me sick, and so did he.

NEAR DEATH

Randy was almost two years old before he started to walk. He would fall from his missteps and bump his head or scrape an arm or leg. He always seemed so off kilter, and one day he fell over backwards and hit his head. He had a goose egg on the back of his head so I put a cold clothe on it. I kept him up in case there was a slight concussion. After only an hour, he started vomiting so I took him up to the emergency room.

My doctor checked him out and admitted him. He had a slight concussion, his blood was 60% lower than it should have been, he was anemic, and he had an inner ear infection. His equilibrium was off, causing him to fall a lot. While he was hospitalized, he caught the flu. He was in bad shape for the first time since his birth. He couldn't keep anything down and he had severe diarrhea.

They hooked him up to on intravenous needle to keep fluids in him so he wouldn't dehydrate so fast. They completely drained his blood and gave him five new pints. His veins were so tiny they called in an Asian doctor who made the teeniest slice in the vein of his ankle to get a needle in. He was on an antibiotic for the ear infection. I stayed at the hospital during the night. By this time I was working at another bar and worked during the day.

He seemed to be improving. My doctor left town on some kind of

convention and did not leave any instructions. When the last IV was emptied, they did not replace it. I was standing in the doorway of his room, holding him, when another doctor walked by and pinched his leg. He started yelling at nurses to get another IV in him. He still had diarrhea and was vomiting, but not as often. By the next day, he was going fast. They called me at work and were going to transport him to a bigger hospital with a more sophisticated pediatrics unit. I rode in the ambulance with him, and Carl was going to drive up the next day.

It was wintertime and storming. The roads were treacherous, but the ambulance was going 90 miles an hour for the two-hour trip. Not even halfway there, a snowmobile shot across the road in front of us and I thought we would all be killed. The driver never touched the brakes. We made the 100-mile trip in a little over an hour.

When we got to the hospital there were different rules, and I couldn't spend the night in his room. I had a cousin who lived not far from the hospital so I called her and she came and got me. When I left, Randy was hooked up to so many wires and needles I wanted to cry. I felt so helpless. I was so afraid my baby was going to die. After him fighting for his life when he was born, I was going to lose him now.

I went to my cousins' and fell into an exhausted deep sleep. I heard ringing and talking but could not fight my way out of sleep. I opened my eyes when I heard my name being whispered, "Brenda, Brenda." I was still half-asleep and thought an angel had come for me when I saw a figure standing in the room with a long white gown. I didn't know where I was and didn't know if I was dead or alive. I let out a blood-curdling scream that sounded like I was being murdered.

In my exhausted state and due to the stress, I couldn't comprehend that the telephone had rung and my cousin had come into the bedroom to wake me up. Carl was on the phone and heard my scream. I finally woke up enough to talk to him. My cousin was pregnant and I put such a scare into her that she nearly miscarried.

The next day Carl drove up and came to get me so we could go to

the hospital. It was still storming and was raining and freezing on the roads. We couldn't make it up a hill to the hospital and finally had to call a taxicab to bring us there. It was the worst experience, so frustrating. All I wanted to do was get to the hospital to see Randy.

During the night the doctor had flushed his whole system out with some kind of ultra-violet substance and he was remarkably improved. He was in the hospital for another three days and we were able to take him home. He was a very fortunate baby. If he hadn't gotten the last IV at our hometown hospital, he would have died during the night. The doctor was an angel in disguise.

SEESAW

One night Carl was out drinking and brought a friend home with him. He was a local political man whom he had confided in. Our marital problems were getting worse. This man was influential and had represented the people for many successful years. He had offered to counsel us but I was skeptical. When Carl went to the bathroom, this influential man came into our bedroom, a brash move, rather assuming of him to do that. I was awake, sitting up in bed, with a skimpy nightgown on. I covered myself with the blanket as he casually sat down on the edge of the bed. I smelled liquor on him but I was trying to tell myself he was a sincere man, just a little intoxicated.

He started talking about the problems we were having, and when he put his hand on my leg, I tried to accept it as a fatherly gesture, until his hand moved to the edge of the blanket. He started working his way under the blanket and toward my bare leg. I slapped my hand down on the blanket to block his advances just as Carl came out of the bathroom. He was so drunk he didn't know what was going on.

I told Carl the next day when he was sober, and he made it look like I had invited the suggestive move. He never believed his friend, an upstanding political man in the community would dream of doing something like that. I must have done something to make him think

I wanted him. After all, I was a "whore."

After some time, I finally kicked him out of the house and filed for a divorce. He went back to his mother's house to live. He quit drinking for the whole time the divorce was pending. I still worked at the bar and he would come in every night after work, drink pop, and beg me to drop the divorce. He tried to convince me he'd changed.

I befriended a woman who came in regularly. We compared stories about abusive relationships. She was married but her husband had been abusive in their earlier years. She had had numerous affairs but was still with her husband. She told me to be careful if I decided to go out with someone. Also, if Carl ever did hit me to cover my face, "Don't let him batter your face." Carl had never hit me but I began to think the potential was there, buried under his fury and obnoxious attitude toward me.

I started dating without his knowledge and went out with a guy my sister Debi introduced me to, she was dating his friend. We spent a whole day just being kids. We went to a park, running and playing on the beach, swinging on the swings. I was missing out on so much innocent and carefree fun. I wrote some poems about the day, the man, and the feelings. He lived in another state and was only in town visiting his father. I had slept in the same bed with him at Debi's house but we never did anything. It was nice to just be held and not be expected to perform circus acts in bed.

Carl was ever persistent. One week before the divorce was final I believed he was sincere, that he really could quit drinking, he had done it for nine months. I thought there was a good chance of working things out. I dropped the divorce. My lawyer suggested I just leave it pending for six months, in case things didn't work out, I would not have to go through the process all over again. He knew more about the odds than I had faith.

I decided to have another baby, which would make everything better for us. My second son was conceived for all the wrong reasons, but I loved him just the same. He was born in January of 1978. It didn't take long for Carl to start drinking again, and it was back on the teeter-totter. If things had changed, I was still living with the

same old shit. I left him again, I took him back. I thought I couldn't make it on my own, but could I survive with him? I actually started thinking about killing him. I thought about tossing the blow dryer into the tub when he took a bath. I was that desperate.

I filed for divorce again a year after I had dropped the first one. Carl refused to leave the house. He quit his job and said he would take care of the boys while I worked. I was up against the wall and didn't want to quit my job. My job was my freedom. My sons, Randy and Jeremy, and my job were my life. The divorce was pending and I told Carl if anyone asked me out, I was going to date. Trying to swallow his anger, he said he would kill me if he ever saw me with another man. If he couldn't have me, no one could. I was living with a stick of dynamite. My lawyer told me I was in one of the most volatile situations I could be in.

A guy named Gregory started coming into the bar. He had just moved to my town and his parents owned a business here. We talked about our lives and he told me he had moved from the city to get away from the drugs. He worked on construction and only came in on weekends. When he asked me out I told him about my situation at home and he understood that we would have to be discreet. We decided to wait until my divorce was final. He gave me his phone number, telling me if I ever needed him, to call.

I was adding to the poems I had written and I kept them in a folder under my mattress. Carl and I were not sleeping together but he was there with the boys every day. For whatever reason, he decided to clean or search, and found my poems. He called me at work and said, "I was making your bed and turned the mattress over."

I said, "So."

He said, "I found your poems." I didn't think it was a big deal, it was just poetry. The silence on the phone was deadening even before he hung up.

When I got home from work, Carl left without saying a word. He came in the house at two o'clock in the morning, drunk out of his mind. I was sound asleep and woke up to his fists pounding into my face. I was screaming and trying to fight him off while fighting my

way through the fog of sleep. Randy, who was four, was sleeping with me. He woke up and jumped onto Carl's back yelling, "Daddy don't. Daddy don't!" He was pulling his Daddy's hair, bravely trying to help his Mommy. Jeremy, who was one, was sleeping in his crib in the same room.

Carl threw me to the floor and started choking me and banging my head into the floor. I kept thinking if I could reach up and grab the bedside lamp, I could hit him over the head. I was struggling to get free, stay conscious, and trying to rationalize my thought of, *what if I kill him?* At the same time I knew I was going to die if I didn't do something. I was almost to the point of giving in to death. I could still hear Randy's screams fading away, "Daddy don't hurt mommy."

I don't know what made him stop. When I realized I was fighting for every breath, but I was still breathing, I knew I had to do something fast so I could get myself, Randy, and Jeremy safely out of the house. Carl helped me up and I did the only thing I could think of. I put my arms around him, and as he was crying, I told him everything was going to be okay, that I loved him, and would stay with him. I waited for my chance. When he walked out of the bedroom, I calmed Randy down and whispered to him that when I told him to, to run to the car with me. Carl was still pacing, and walking back and forth in and out of the bedroom. He finally went into the bathroom.

I took Randy's hand, grabbed up Jeremy out of the crib, and ran to the car. I kept an extra set of keys near the door. I got into the car, shoving the boys into the front seat with me. Just as I put the keys in the ignition, Carl was running out the front door roaring. I reached over and locked the passenger door just as Carl reached for the handle. I sped off with him screaming, "I'll kill you." I found out later my next-door neighbors heard me screaming for my life, and never bothered to call the cops!

I was in shock by this time and drove down the street, and kept driving around the blocks in the opposite direction, until I got to the state police station, which was only one block from our house. It was late fall and I only had a long silk nightgown on, with bare feet.

The boys had footy pajamas on. I pulled up in front of the police station and laid on the horn until I saw an officer in the doorway. I grabbed the boys and ran into the station. I was hysterical. I could not stop shaking and screaming. One of the officers sat me down and put a coat around me while the other one took Jeremy from my arms. I told him what happened and they called in the City Police.

When the City Police arrived, he just looked at me and said, "Did Carl do this to you?" He asked where he was and I told him he was still at our house. They went to pick him up and instead of taking him to jail, they took him to his mother's. They came back to the state police station and told me they took him to his mother's and asked if I had someplace to go. I said I would go to my parent's house.

I woke my Mom and told her what happened. She had been through so much abuse herself that she was very consoling, and felt terrible for me. We put the boys to bed and sat up talking. She would tell my Dad what happened. I was exhausted and just went to bed. It never dawned on me to look in the mirror to see what damage had been done. I just knew my face was throbbing and I could barely see out of one eye. The words of advice of the woman who frequented the bar came back to me; *don't let him batter your face.* It was too late for that.

I got up the next morning when Dad got up for work, and he never said a word to me, could not even look at me. He left for work and I went in the bathroom. When I looked into the mirror I knew why Dad couldn't look me in the eye. I felt sick to my stomach when I looked into an image of a stranger with a black and purple face, my right eye nearly swollen shut.

I went to my doctor so he could take x-rays. The top and bottom bones of my eye socket were chipped. He said my face would take weeks to heal but I was lucky, I didn't lose my eye. I was now a battered wife. I called my lawyer and we pressed assault charges against Carl. He spent three days in jail. It didn't seem like enough, but it was something. I had a restraining order against him, bringing with it a temporary euphoria. He was now permanently out of the

house.

I was so ashamed. I didn't want to show my face anywhere. I called my boss and told her what happened and quit my job. I went to Social Services and got on welfare. I went to visit the woman from the bar, telling her what happened. Her husband was there and told her after I left he did not want her to have anything to do with me, not to get involved in my problems. Then I hid in my house for two weeks, waiting for my face to heal.

ONLY THE BEGINNING

When Gregory first walked into the bar, I didn't know why but I was immediately attracted to him. He was six feet tall, deeply tanned with muscular arms and shoulders, and a sensuous smile, but the sway in his walk seemed out of place. This blue-eyed blonde had smooth skin with a mustache that looked too harsh for his face. He had an innocent little boy look. One that works on Mommy, but also one that said "You know you want me." It was strange, but I did, in an uncomfortable way. The chemistry between us would gradually become a magnetic force of obsession.

We would pass the time in the bar talking, laughing, and playing the jukebox. He was an incredible flirt, matching my expertise. When our bodies would brush together briefly while we chose songs, the chemistry would explode between us. Our eyes told us the feeling was mutual. With my divorce pending, I didn't want anything to come of it so soon, but I knew it eventually would. It was my first encounter with pure lust.

I told Gregory that I had two sons. I told him I was going through a divorce but my husband was still living in the same house with me. I told him my husband drank heavily and was extremely jealous and verbally abusive. I told him I had flirted in the five-year marriage, but had never had an affair, but Carl was convinced I was leaving

him for another man. I told him he had threatened to kill me if he ever saw me with another man. That is when we decided to wait to see each other until after the divorce. He gave me his phone number but I never called him.

Gregory's nickname for me was "Lady" and I was beginning to feel like there was a man who would finally treat me like one. One Saturday night Debi and I were at a local dance club when Gregory walked in. He walked up behind us and said, "Would one of you ladies like to dance?" When I turned around he was looking at me with his bright blue eyes. The butterflies in my stomach did cartwheels and every dance was ours.

We danced slow to fast songs and were oblivious to the people around us, continuing to dance when the music stopped. Our bodies melted together in the embrace of passionate savage lust. The heat our bodies generated soaked through our clothing until we were wet with desire. We sent unspoken suggestions with our eyes and our bodies responded. He whispered, "Oh Lady, I want you so bad." I went home that night anticipating our inevitable tryst.

It was the following weekend when Gregory came home from his job and learned that I had quit my job but didn't know why. It took him two weeks before he finally got my boss' son to give him my phone number. He called me and when he found out what happened, he was upset and felt it was his fault. It was a drunken insane attack that really had nothing to do with him.

Against my lawyer's advice I started seeing Gregory. I met him at a bar that night and we ran into Carl's sister. My eye, even after two weeks, was still badly bruised with every shade of green, yellow, and purple. She told me she was just sick about the whole thing. She couldn't believe her brother had actually gone that far with his abuse.

Gregory lavished me with attention. He took me to dinner, to the movies, sent me cards, and brought me roses. I had never gotten flowers from any man and I was thrilled. He made me feel so special. Everything seemed like a fairy tale with him. I knew it was too soon after a disastrous marriage, but we had the understanding that we would not tie each other down. We would still be free to date other

people.

I was out with my sister-in-law one night when I met Ben. I had noticed him walk into the bar and he was gorgeous! We started talking, he bought us a drink, and when my sister-in-law wanted to go home, Ben asked if I would go with him to a club that had a live band. Ben lived five hundred miles away and he was leaving in a few days. We went out for the next three nights and neither of us wanted to say good-bye.

We spent our last night together dancing at the same club. We were on the dance floor when Gregory walked in. He had been at his Dad's hunting camp and was drunk. When he saw me in another man's arms the look on his face was a mixture of hurt and fierce anger. His eyes penetrated me with such intensity it could have drilled me through the wall. When the music stopped and Ben and I sat down, I was shocked when Gregory came to our table. He asked me to go outside with him. Ben was concerned but I assured him I'd be fine.

Gregory was furious when I refused to leave with him. I kept reminding him we had agreed to see other people. He said, "I never thought you'd do it, you are mine!" He left in a rage when I told him I was going back inside with Ben. He left screaming, "You'll never see me again!" Part of me didn't care if I never saw him again and part of me knew I'd be alone when Ben left, and my deepest fear surfaced.

Ben and I promised to write and he planned to see me in two months. He was bringing his four year old son on a fishing trip. He had just gone through a divorce and was fighting for custody. I wished him luck and looked forward to seeing him and meeting his son. We spent most of the night in his motor home, him reading some of my poetry and wondering at the power in my words. I wrote about death with a vengeance back then, stemming from the loss of Mama. He made love to me and we sealed our promise to stay in touch and continue to see each other when we could. He was a very gentle man. I knew in my heart I could love this man, but I never got the chance. The only reason being my own, and Gregory's influence.

KNOWING GREGORY

A few days after Ben left, Gregory called and apologized for his behavior, admitting he had no right to act that way. I thought he was sincerely sorry and when he brought me a rose, I believed him, and once again, his attention fed my need to feel wanted and loved.

We learned everything about each other. Gregory told me his past, the fact that he had been a junkie for ten years and had been clean for the year since he'd moved out of a major city. His drug history began with sniffing model airplane glue and gradually led to smoking pot, then to heroine and speed. He spent most of his teenage years in juvenile homes, jail, and finally had to join the Marine Corps to keep from going to prison. He only lasted a year and was given an "Undesirable discharge." For the next ten years he was a permanent fixture on the streets, with a needle in his arm, doing anything he could for a fix, including arson, stealing from his family, having sex with a man, and any number of petty crimes. He lived with other junkies in filthy conditions.

I had never been exposed to anyone with that kind of experience with drugs. I admired his courage and strength, and never once doubted he would be successful at leaving his drug habit behind him. We small town girls are so naïve, so easy to totally trust someone.

The first time I slept with Gregory was dreadful. Nothing like the

delight we displayed on the dance floor. I couldn't relax, I cried and felt guilty, but he knew all the right words to say, everything a woman wants to hear. He helped me feel comfortable about where *he* wanted our relationship to go, knowing I did not want to fully commit.

When he was laid off for the winter months, we started spending most of our time together. He made me feel loved and I got high on the unquenchable ecstasy he brought out in me. He created a monster and I couldn't get enough. I was sinking into a trap of quicksand that soon became a bottomless pit.

Ben wrote to me and called me several times, and I kept my correspondence with him a secret until a Christmas card arrived when Gregory was at my house. He was upset because we had been spending so much time together. He assumed and I guess I let him believe he had me all to himself. He told me he thought I should make a choice. "After all" he said, "I am here for you all the time, this guy is far away, what can he do for you?" I felt guilty and finally gave in to his wishes. Giving in to Gregory had become a part of me I didn't like. I was making my bed of perdition again.

Sad regret filled my heart when I wrote Ben for the last time. I told him I was happy with Gregory. Ben called me; he wasn't willing to give up on us. Gregory was there when I got the call. I told him, "Yes, I'm happy." That lie haunted me for years. The lump in my throat hurt even worse when I could not allow myself to cry, for fear Gregory would know my true feelings. My happiness could have been with the receiving end of that letter. Ben could have been my salvation from the grotesque illusion Gregory was hiding from me.

Thinking I could love Gregory, I tried to be happy with our relationship as it was. He was still winning my trust and respect, as he was thoughtful and perfectly lovable, and he was wonderful with Randy and Jeremy. He would take them fishing, hunting, and camping. He was winning me over through them. He became my hero when Carl started sitting out in front of the house at night, calling me to say he had a shotgun and was watching me. Gregory would spend the night to make sure nothing happened to me and the boys. We had to call the police several times and I lived on the edge

of panic.

Gregory casually started asking personal questions about my past, particularly men. He wanted to know how he compared, the things I had done with them, if anyone had ever made me feel the way he did. Because he knew Ben was out of the picture, he became overly possessive. He also knew he could influence my responses. He became more controlling, even to the point of telling me how to dress. He insisted I destroy all the wedding pictures of Carl and me. I was saving them for Randy and Jeremy but I gave in to his persistence. He criticized me for wearing jeans and tee shirts. He thought I should wear dresses all the time. I was tomboyish, I hated dresses, but I agreed to start being more feminine for him. He wanted me to wear a particular brand of panty hose, only nylon panties, and I had to wear long silk nightgowns, even in the winter. He wanted me to sit in such a way that allowed him to see up my dress when I did wear one. I went through metamorphosis and he controlled it. My life became a speck of meat in a Venus flytrap, a moth in a spider web struggling to be free until finally succumbing to the fate of being subdued into a passive captive.

Gregory seemed happier when I tried to please him and convinced me that I was the most important thing that ever happened to him. He never had a relationship that lasted longer than a year, and he wanted ours to be special. He progressively moved into my life, my heart, and my home.

I kept trying to convince myself that what I felt for him was love. He tugged at my heart. Sex was not a problem. He could send me into orbit by pushing all the right buttons, buttons I didn't know I had. I would crave his touch and cling to the sexual overtures that were always between us. I'm still not sure if it was love or if I became addicted to sex. He knew my body better than I did, and he knew how I would react because *he was reacting for me.* His mouth always moved to the same intimate place where he would linger long enough to make me beg for the pleasure I knew was there. He knew how to pleasure me and he knew the vise he held me in.

When spring came, Gregory didn't get called back to work for

the season. I found out later it was because of his drinking on the job or not showing up for work after a night of drinking. He had given up one bad habit for another. The rejection weakened his ego and he started to party with his friends and drink more heavily. He spent less time doing "family" things and was distant with both me and the boys.

I wasn't important anymore and became a whore in his eyes. He had pressured me into telling him about the men I had been with in the past, before my marriage, and now he used it against me. I became worthless, not only in his eyes, but in my own. Nothing I did was good enough for him. I knew I had gone from the frying pan into the fire and I was left with scar tissue on my heart. It was a constant and seemingly endless whirlwind of fighting and making up, with him leaving or me kicking him out, and him always coming back with flowers that would wilt and promises that would die. His sister followed him to a motel one night and caught him with a girl he had picked up in a bar. She told me about it but he denied having done anything with her.

With the mind games began the power struggle that would dominate our lives. My reality became my worst nightmare and my worst nightmare became my reality, and the sad part was, that I was pressed into a lifestyle that did not allow me to distinguish between the two.

By the time I found out Gregory was doing drugs again, he had already been doing it for several months. He was buying diet pills from a friend of his, cooking them down and shooting up with needles he would steal from a diabetic neighbor. Another neighbor believed him when he asked for needles to give his dog shots. One time he even got them from the drugstore with a story about a customer who was staying at his parents' that was diabetic but could not get to the store. I was shocked he could be so convincing. I was not the only one that was so easily swayed his way. I never knew when he was high. I didn't know what to look for.

I tried to convince him to get help, to go to counseling or get into a treatment center. He always convinced me he could quit the drugs

on his own, but always started again. Once the trust was broken, I never got it back, only pretended to believe. He always used the excuse that drugs made him forget about his real self, when in actuality, he could be his real self because of the tremendous rush he got when he pumped speed into his veins. It excited him and the feeling accelerated his desire to be transformed into a woman. I didn't know it, but the man I thought I loved, the man consuming my life, was a cross-dresser.

SKELETON IN MY CLOSET

Gregory came in one night and sat on the edge of the bed whimpering like a little boy, sobbing something about his mother telling him he was a bastard, she didn't know who his real father was. His mother was drunk and told him with all the class she could muster. Gregory had a stepfather and as far as he knew, his real father had left his mother when he was two years old.

His mother had been in the Marine Corps as a young girl. She was wild and slept her way to the top with the "brass." She was sleeping with all the Generals and Colonels and was dating a Brigadier General when she discovered she was pregnant. He married her and five months after she had Gregory she became pregnant again. When his little sister was only a couple months old, the man he considered his father, left. She put in for a discharge and went home to her parent's farm in Ohio. There, she met and married Gregory's stepfather. His blood father could have been any one of many. I don't even know if that story was truth or wicked words of deceit from a woman who manipulated his life.

He sounded so pathetic. I felt sorry for him. I knew he had his problems and thought I could be the one person to make a difference in his life. I thought things could be good if I tried harder to understand him. I always saw in Gregory the kind of person I knew he could be

and not the person he really was. I thought I could help him work through the problems stemming from his childhood.

As we talked, he worked into the conversation what he'd wanted to tell me since we met. He said he liked to dress in women's clothing and had been doing it since he was a small boy. His mother would put dresses on him, fix his hair, and tell him how *pretty* he was. He slept with his mother until he was six years old. He would rub up against her body, liking the feel of her silk nightgowns. He would become aroused and even as a small boy, would get an erection.

When he was four, an older cousin forced him to perform oral sex on him, but before he did, Gregory put on his aunt's silk nightie. I wondered what triggered that response in such a small boy. I found a new bond, knowing we had both been molested at such an early age. By the time he was seven, he was dressing up secretly. He would wear his sister's panties or put on his mother's nighties. Whenever his mother did dishes, he would lie on the floor beneath her and look up her dress. She never discouraged this behavior until he was twelve, when he sexually molested his three-year-old sister. His mother caught him in the act and chose never to reveal it to his stepfather.

I asked Gregory if his mother had ever had sex with him. I knew this kind of thing happened and the way he described his mother's behavior with him, I thought it was a possibility. He couldn't remember but I think there were things safely tucked away so he wouldn't be hurt by remembering, something like what I had been through. I wondered if her first husband hadn't discovered something about her that was unnatural, and that's why he left. His mother played mind games too, but she was always there to defend and protect her "little boy" from whatever trouble he got into. She had a million excuses for any derogatory behavior he displayed as a boy, and now, as a man. She never made him take responsibility for his actions, and I was not going to pick up where she left off. I will always believe she was the insensitive root of most of his problems.

Gregory told me he had been wearing my lingerie secretly under his clothing since we started living together. I started having flashbacks. Many of my clothes had come up missing over the past

nine months, and I had blamed the babysitters. Things were always moved around in my closet. Panties and nighties were always in the hamper when I knew I hadn't worn them. When we made love, my nightie would always end up over his chest or across his back after he took it off me. Little things began to make sense but make no sense at all.

I was shocked and felt sick when he told me that he not only wanted to dress like a woman, he wanted to BE a woman. He said whenever he saw a little girl in a dress he felt like he got robbed, like he missed out on all those years of wearing frilly dresses and lacy panties. The drugs were the least of Gregory's problems. I was in a relationship with a perverted man who wanted to be a woman. *What the hell had I gotten myself into?*

Through the spinning nauseous fog surrounding me, I could hear Gregory crying and I was feeling sorry for him. He was apologizing and I was believing him. He was touching me, turning me on, and I was wanting him. I wanted to make him feel safe and because I loved him and wanted to please him, I let him put on my panties, pantyhose, and a nightie. I let him cling to my body, touch me with his cold clammy hands, and enter my body. At that moment, I nearly regurgitated on the repulsion I felt for him, and myself. I didn't like this. I couldn't do this. I couldn't stop. I think I would have felt more comfortable being with a woman, not a man in women's clothing. I screamed silent screams, clenched my teeth, and let him finish. The tears on my cheeks branded my soul. I felt like a scarlet woman, contaminated with the worst kind of sin.

I thought our relationship would survive if I just accepted the way he was and tried to be more sensitive to his feelings. When I did that, I put my own feelings aside. He promised he'd never do it again, or ask me to be a part of it. I thought it was just a fantasy he had hoped to have fulfilled. I didn't think it would become an overpowering issue with us. In the back of my mind I wanted so badly to be strong enough to get him out of my life. More importantly was not feeling like I was a failure again. To him, everything was a game. For me, it was a way of survival. I knew his mind was warped

and I always tried to stay two steps ahead of him.

When I decided to see a counselor, I learned the term "cross-dresser." Psychologists in the US have decided that cross-dressing comes within the normal range of male sexuality unless it becomes compulsive obsession. Gregory fell into this category. Gregory came with me several times but I knew he was only humoring me. Sometimes he would wear things under his clothes without my knowledge, sit in the counselor's office with a smug look on his face, and tell me when we got home, "I'm wearing your panties." It wasn't enough that he was doing it in secret, I honestly think he found a sick satisfaction in throwing it in my face. When it came to the point of him revealing his feelings and all the deep dark secrets, he quit the sessions. I continued going and it became my only link to sanity. It became my problem, not his, and I hoped that by helping myself, I could help him.

He started having run-ins with the law. My brother, Roger, and Gregory were working for a logging company and decided to steal a load of cedar logs. They sold it to someone for $100.00 to have money to drink on, and for Gregory's drugs. They got caught, went to court, and had to pay fines and restitution.

Another time I was awakened in the middle of the night by loud voices and flashing lights in front of the house. When I looked out the front window, I was taken aback to see Gregory and Roger standing with their arms in the air and a rookie cop with a gun to my brother's head. I could hear Roger laughing and asking, "What are you going to do, shoot me?" I was afraid to open the door, afraid the cop would shoot me! His hands were shaking and my brother was bobbing around. He thought it was a joke, and both he and Gregory were drunk.

The cops finally got them both handcuffed and into the squad car and I opened the door to ask, "What the hell is going on?" The cop told me that a television set had been stolen from a motel room, along with a camera belonging to the men staying there. Gregory and Roger fit the description of the two guys. I couldn't believe they would do something so stupid! When the officer asked if he could

look in the trunk of the car I said, "Go ahead!"

By this time I was enraged enough to help them out, but there was nothing in the trunk. He asked if there was anywhere they would hide the stuff, if they had stolen it. I sent them to Roger's cabin. They found the television and camera, and they were both charged with theft. Gregory's mother bailed him out of jail and Roger posted his own bond. When the court system sent for Gregory's rap sheet from his previous hometown, it came back about nine feet long when it was unfolded. Everything from auto theft, arson, counterfeit money, and drug charges, breaking and entering. His whole useless lawless life, from juvenile to adult, was on a piece of paper for the world, and me, to see. They both pled guilty and spent some time in jail.

AND THEN THERE WERE FOUR

Gregory had told me he could not have children because he was born with hypospadias, which is a congenital malformation in which the male urethra fails to fuse completely on the underside of the penis, so there is a trough-like opening instead of a closed tube with the opening at the head of the penis. This happens in one of every two or three hundred male births, some being a little more extreme than others. When the urethra opens before it reaches the tip of the penis, a boy may be unable to stand and urinate with a direct stream, thus having to sit on the toilet to pee. It places the boy at an acute social disadvantage.

Gregory told me he had tried unsuccessfully to have a baby with other women. I went off the pill in the hopes of being the one woman who could give him something that might make him feel like a complete man, and hopefully end his desire to be a woman. I believed in miracles when three months later I found out I was pregnant. I found out that Gregory had indeed gotten a woman pregnant, his cousin's girlfriend, and she had an abortion. I knew the importance of my having a child was actually another part of the secure hold he had on me, and wanted to keep on me. I know now that hypospadias does not cause infertility in men.

When I was six months pregnant, I found out Gregory was buying

diet pills from a woman, and through my counselor, made sure that her doctor found out about it. She lost her prescription. He found another source. He started hanging out with a young couple who had recently moved to our town. He tried to bring them into our relationship so we could all be friends. I knew they were just a couple of young druggies and didn't want anything to do with them. In 1981 we were married, and one month later our son Matthew was born.

Gregory continued to drink, do drugs, and cross-dress, and we still fought with a vicious struggle for control. At times he was happy, content, and proud of his family. He had even gone to natural childbirth classes with me so he could experience the miracle of birth. I thought he would be a good father. Other times, he was away from home for days at a time, leaving me with no transportation, no money, and sometimes no food in the house. We were on welfare and the only time he worked was when he wanted money for drugs.

The young couple he had befriended lived two blocks over from us. He had been spending most of his time with them. I found out the guy was out of town looking for work and Gregory was still spending time with the girl. I did the unthinkable one night and left my three boys alone while they were sleeping. They were seven, four, and one years old. I ran over the two blocks to their house and tried to see in the windows. I knew in my heart there was more going on then the drugs. I was sure he was bedding this young girl while her boyfriend was gone. I couldn't see in through the windows but when their Doberman started going crazy and barking inside the house, I ran from the yard, and back home. *Was I crazy?* I knew I was on the brink.

I focused even more attention on the boys, and I slowly lost interest in trying to solve Gregory's problems. I was torn between wanting to please him by fulfilling his desires of being a woman, and not wanting him to touch me with his perversion. Whether cross-dressing was normal for the male sexuality, his behavior was not healthy for our relationship, and the wedge was getting deeper between us, causing pain and discomfort for me.

Gregory's stepfather got it into his head that Matthew was not

Gregory's baby. Gregory's mother was the one who had told him he could not have children because of the hypospadias. Now I knew where he had gotten the conclusion from. I believed in confronting the enemy so I called his stepfather over to the house and asked him, "Is Matthew your grandson?" He didn't know what I was leading up to. He hemmed and hawed, trying to duck the subject but I kept badgering him until he admitted his doubt. Matthew looked identical to Gregory's baby pictures, there was no doubt, plus the fact that I was not unfaithful to Gregory even though I thought he was. I was hurt and never felt the same way about his stepfather after that. He still has not gained my trust and respect.

I believed Gregory loved me in his own disillusioned way, but he was incapable of giving and receiving love. He felt anger, resentment, jealousy, and hatred toward me, and I became a threat and reminder of everything he could never be. He started taking his frustrations out on me in an indirect way. On two different occasions, he sliced four pair of my dress slacks to shreds with a knife, and ripped one of my silk nighties up the front, throwing it in a corner of the bedroom.

He went through cycles of not dressing up for long periods of time, to his making demands of me to be involved with his quirks. Sometimes he just wanted to lie next to me while wearing my lingerie, other times he wanted to dress up and have sex. He bought me a lace teddy for Mother's Day one year. I knew when I opened the package it was about three sizes to big for me. He had actually bought it with himself in mind. What a slap in the face. He became progressively worse over the years, from only wearing panties, to wanting to wear dresses, wearing make-up and shaving his legs. Several times he shaved his pubic hair. I grew to hate him and was revolted by his touch or even to look at him.

I went through periods of rebellion, a tug-o-war between wanting to please him and refusing to let him touch me. Some nights I would wake up and reach out to touch him, only to find he was wearing panties, pantyhose, and a nightie. I would cringe and move to my side of the bed. With clenched fists I'd pray he was asleep and didn't want me. Other times, he would use guilt to torture my mind so he

could get what he wanted sexually. He threatened to reveal the horrible secrets from my past, the ones you now know. I had confided in him, and now he used it against me. Still other times he would take the car keys; refusing to let me leave the house until I gave him what he wanted – me.

I loved my children more than my own life, and when Matthew was a little over two years old, I wanted another baby. I don't know why I chose to bring babies into my messed-up world. I knew I could love them and they would love me back. I was a good mother and my children were feeding my hunger for love, and filling the void in my life that no man had done. Appearance wise we were a normal, healthy family, but no one knew the monster I lived with, one that was sucking me dry of the blood that sustained me. I had promised Gregory I would never tell anyone outside a counselor about the flaw in his character.

When I was six months pregnant with our second baby, Gregory tried to commit suicide. He had ridden up into the woods and swallowed a bunch of pills. Miraculously he drove the twenty-five miles back to town, running on the fumes of an empty gas tank. It was a desperate cry for help and after he got his stomach pumped, he checked into a rehabilitation center for six weeks. In going through the drug treatment, he still refused to look more deeply into his obsessive-possessive behavior or his cross-dressing.

When I told his mother he was in drug rehab she said, "I didn't realize his problem was so bad." I also told her about the cross-dressing and she said, "That doesn't surprise me." If someone ever told me that about one of my sons, it would floor me! Her lack of reaction floored me.

He completed the program and came home with a new determination to stay clean, stop cross-dressing, and be a good husband and father. I found a journal he had written in rehab and learned of his affairs. I forgave him. Three months later, in 1984 when Caleb was born, I had my tubes tied and Gregory started getting high again.

ANOTHER INNOCENT CHILD

Gregory started hanging out with a neighbor. They worked on cars and of course both shared the habit of smoking pot. The neighbor was married with two sons, one around the same age as Matthew, who was four, the other who was seven, so the boys played together. One day Matthew was across the street with the older boy, supposedly playing on a swing set in the back yard. I went to check on them and they weren't on the swing. I knocked on the neighbor's door and they weren't inside either. The woman thought they were in the backyard.

As I walked outside to check the back again, I saw Matthew and his playmate inside the neighbor's car. I opened the door to take him home with me. He started crying as we crossed the street and walked into the house. I thought he was upset because he couldn't stay and play. I asked him why he was crying, and I noticed he was rubbing his groin area, and then I saw that his pants were unsnapped and partially unzipped.

I got him calmed down and asked what happened. He said, "Bobby bit my pee pee." Trying to stay calm, I pulled his pants down and was aghast. His penis was red, bleeding, and had tiny teeth marks. I took him to the doctor right away, I was afraid because I knew a human bite is sometimes worse than an animal. Matthew would be

sore for a few days, but he was fine. There were now three of us connected with the same age of being touched inappropriately. Four-years-old was a bad omen, one of the snags in the thread.

When I got home, Gregory was home and I told him what happened. I wanted him to go talk to his friend about what Bobby had done to Matthew. It was his friend and I thought it was his place to do it, but he refused. I wanted to slap some sense into him. I was so angry. I decided to do it my way. I called Child Protective Services and told the worker what happened. In her experience, she found that when girls are molested at a young age, they become withdrawn and promiscuous at an early age. Boys on the other hand, tend to repeat the behavior. The social worker thought it was possible that Bobby was being molested because he performed such an aggressive act, biting Matthew's penis.

She assured me she would get involved and go speak to Bobby's parents; she suspected the mother. As far as I know, she did talk to both parents, but nothing came of it. Gregory was perturbed with me for what he thought was my trying to sabotage his friendship. He would rather ignore what happened to his own son then be a father and give up his smoke pal.

Matthew didn't seem to suffer any ill affects from the experience but he was not allowed to play across the street anymore. Just as no one was able to protect me from harm, I was unable to protect my son from a violation of his innocence. I don't know what lead up to the seven-year-old boy's actions. Possibly he was molested, or he witnessed his parents in a very intimate act, and repeated what he saw.

BROKEN PROMISES

The vicious cycle of Gregory's sickness went on and on. I begged him to leave, to find a society where his behavior was acceptable, and he could openly live as a woman if he chose to. I told him to go find a woman who could let him be himself. He didn't want to give up the appearance of having a normal family, he wanted to stay with me, and he would.

He always said he loved me and that he could stop his behavior. I heard it so many times. His words fell on deaf ears. He would insist that the boys and I were the most important things in his life, but he hadn't proved it to me. I believed we were important to him but we always came last.

I filed for divorce but never ended the marriage, always hanging on to any shred of hope I could find, convinced I loved him enough to be strong for him. My counselor told me I was a martyr and was concerned for my safety, not only from Gregory's hands, but my own as well. I talked about wanting to die. I know the only thing that kept me from taking my own life was the thought of what would happen to my boys. One thing my counselor said always stuck in my mind, "You aren't helping him by staying with him. If you let go, maybe he'll get the help he needs."

I received a brochure in the mail, from a church offering Bible

studies, and decided to go. I found a new love and decided to join the church. I had been raised Catholic but hadn't gone to church in years. The people in this particular church lead simple lives and welcomed me with open arms. I was at peace and quit going to counseling. I became very involved in the church, with meetings, programs, and teaching the children. I also took on the duty of secretary/treasurer. My needs were being fulfilled away from home, but I still felt like I was living in Satan's domain at home.

Each time Gregory gained more ground in his identity, I lost more of mine. I felt like he was becoming me, and I was suffocating into nonexistence. I had alienated myself from my family. I didn't want anyone to guess things were so bad for me. No one at church knew the hell I lived with, I didn't testify in church to any factors in my private life. I lost my identity, my personality, and most importantly, my femininity. I maintained a front for everyone who knew me, but inside I was a wretched mess. Whenever Mary would visit in the summertime, she always mentioned how depressed I was, and that I should be on medication. I never pursued it, just lived with the consequences of my life.

Gregory and I decided to buy a house in the country and went through FHA. I owned the house in town and because of the qualifications for that type of loan, we could not already own a house. I had a clear deed to my little house in town, so I gave it to my brother Roger. We bought a four-bedroom with 0% down, no interest, and extremely low payments.

I finally confided in my best friend in the church, telling her about Gregory, and she became my strength. She was horrified and felt the ache in my heart. It was a burden that one person should not have to bear alone. Somehow my life seemed easier, knowing that God could change people, and He would give me the strength to endure to the end. I believed this with all my heart, but I also knew God could do nothing unless Gregory wanted to change. I was close to God at this time in my life and had reached a point in my spiritual life. I no longer believed in divorce, and Gregory knew it. He thought he had the perfect woman. I was a born-again Christian, I didn't drink or

smoke, and went to church faithfully. I told him he could put me through hell, and I would not divorce him. He did his best to take me on a private tour through the bowels of a burning hell.

When Gregory knew I was becoming closer to my friend Danielle, he sensed I had told her about him. His safety net was threatened. Maybe he sensed I would become stronger, and he didn't want anyone's positive influence in my life. He decided to go to work in the lower part of our state, and eventually move his family there. It was his way of taking *my* safety net from under me, so he could watch as I slowly plunged into self-destruction.

When Gregory was home one weekend in November, for deer season, we took a ride up in the woods to my dad's hunting camp. My old fiancé Brad was there. I hadn't talked to him in years, and we started talking over old times. He even remembered when my birthday was. I could tell that Gregory was getting jealous and upset because Brad and I were having some laughs. I went home wondering what my life would have been like if I had married Brad. He was still a nice guy. He had gone through a divorce, too.

Gregory left and went back to work, about 300 miles away. My life was so peaceful without him. I talked with my sister Debi and told her I had seen Brad. She told me that he still talked about me with her, that he still cared for me, after all these years. I saw Brad again at my dad's camp. We went out to a camper trailer and talked. He told me he had never gotten over me, that he used to dream about me, and had called his wife by my name several times. I didn't want to believe that it was just a line, that he was just saying what he thought I wanted to hear. I believed he was still in love with me. We started kissing and he told me my lips were as soft as he remembered them. When he put his hand inside my shirt and touched my breast, it was like we had never been apart, until I regained my dignity and remembered I was still married. I knew I was treading on dangerous ground. The seeds of temptation were planted. I went home and could not stop thinking about him. It seemed like every time I went somewhere, I would see him go by in his truck. I knew I had to keep my distance.

Gregory was gone about two months, supposedly working, although he never sent any money home. I was still getting a welfare check and was packing our things in anticipation of moving, and hopefully starting a new life. Gregory was supposed to be staying with his aunt or a cousin, and I found out from his aunt that he was spending all his money on drugs and partying all night. He would never admit it, but I knew he was seeing other women. He wasn't writing or trying to contact me. We did not have a telephone, but there were places he could leave a message.

The devil was plundering away at my life, picking away at me like a buzzard in the desert. We were losing our house. I had received foreclosure papers because we were behind on our property taxes. I was raising four boys on my own. We heated with a wood stove so I had to haul and split wood, and we were running out of the wood supply we had. I had sold off most of our furnishings and packed and unpacked three times, waiting for the move. When I had a chimney fire in the middle of the night, and had to rush the boys out of the house to the neighbors, whatever was holding me together finally snapped. I hadn't smoked cigarettes in six years, but I started again.

I felt as if God had let me down, and I turned my back on Him. I wrote a letter to Brad, wanting to see him, thinking that he would miraculously help me get away from the monster I was married to. I knew I was going to have sex with him. I called him before I went to his house, to make sure he was alone, and it was okay. I left the boys with a babysitter and went to his house.

It was too brief to classify as an affair. It was a one-night stand that left me feeling dirty and cheap, a feeling so familiar to me. It nearly destroyed me. I didn't even use his bathroom to clean myself. I left almost immediately, feeling like I had committed the worst degradation. I felt like a whore, and in more ways than one. I wanted to kill myself. I went home and soaked in my tub, the water as hot as I could stand it, the way rape victims do, and I cried myself into exhaustion.

What hurt the most and brought the most guilt, was that I had

betrayed God. I wrote to Gregory and told him our marriage was over, and not to bother coming home. In my mind, I had done the one thing that would finally end it, even though I had no intentions of telling him. A week later, he left a message with a neighbor for me to call him. I stood in the cold, shivering in a phone booth, and spilled my woes to Gregory, all but the part about Brad. He listened to all this on the other end of the phone, and was able to sense the only thing that really concerned him. He asked, "What did you do, go fuck someone?"

I told him, "Yes." And as I fell off the pedestal he had put me on, he hung up the phone.

He was home the next day and threatened to kill me if I didn't tell him who I had slept with. He didn't believe my made up story about picking up some guy in a bar, he knew me better than that. He threatened to tie me up in the basement and leave me there until I told him the truth. I stuck to my story. He never hit me, but he held me down until I was hysterical, paralyzed with fear for my life, and what would happen to the boys. I stuck to my story. I felt like I was being held under water, with that claustrophobic fear of dying. I stuck to my story. I thought I was going insane. I had such a distorted perspective of my life. I believed I could not function without him. When he said he was leaving, I thought if he walked out the door, I would kill myself.

I finally told him about Brad, and he was even more indignant because I had made up a story and tried to protect him. He said he could forgive me for what I did, but not for trying to protect Brad by lying. He forced me to write on paper every detail of what Brad and I had done leading up to, during, and after we had fucked. He wrote on the bottom, "You had my wife, now I want you." He put it in Brad's mailbox, which he in turn, took to the police.

I went to Danielle's house and spilled my guts about what happened and she was as devastated as I was, but she was there for me. I called Brad from her house. He couldn't understand why I had told Gregory. I learned then what had become of the paper Gregory had made me write. All I could say was, "I'm sorry." I knew no one

would ever understand why I did what I did, not even me.

Gregory left and went back to where he'd been working. I moved out of the house and into a low-income housing project. In the dead of winter, in the middle of a snowstorm, Dad helped me move what meager belongings I had left. Brad was good enough to plow the driveway of the house I was moving into, only after Dad asked him to. Dad and I stopped at a bar when we had the last load on the truck. He said, "Brenda, don't make a fool of yourself."

I said, "I already did." We never discussed it, but I knew Brad had probably told him what happened.

Two weeks later, Gregory came home. He had quit his job and said he missed his family. I decided I owed it to him to try once again to make our marriage work. He agreed to start coming to church with me and the boys. The extravagant price we pay for wanting to believe in something good. For the next ten months, I danced the tango with the devil.

UNFORGIVEN

Many times, Gregory threatened to shoot Brad, run him off the road, or beat him to death with a baseball bat and make me watch. He said he had forgiven me, but it ate at him like a cancer. I don't know how many times I had to beg Gregory not to hurt Brad. There would never be anything between us. I would never be able to look him in the face again. It was my fault he was in danger and he may not have known how close he came to death at Gregory's hands. Gregory did encounter Brad one day and forced him to pull off the road, but his brother, who happened to be driving behind him, came to his rescue.

Now Gregory had power over me for his own sick pleasure. He made me play his sexual games and treated me like a disgusting bawd, and in return he always promised not to hurt Brad. He kept his promise, and I paid for it in the most degrading way. Whenever we would go to his parents, or go to town for anything, he would drive by Brad's house, going out of his way to do it. He went out of his way to shove it down my throat.

It didn't take long for Gregory to meet a guy down the road from us that sold and smoked pot. He had a new crony. He quit coming to church and spent all his time at his buddy's house, smoking dope. One time after he was gone for two days, I called the guy's house

and talked to his wife. She said she had no idea where they were, she hadn't seen them in two days. I said, "You mean to tell me, your husband has been gone for two days and you don't even wonder where he is?" She didn't seem to care. Later I found out they had gone into another state to bring back a load of pot. They had to cross a bridge to get home and if I had known, I would have had the state police waiting for them. They brought back a bunch of marijuana to sell. When I threatened to call the cops, Gregory told the guy and he flushed it all down the toilet. That satisfaction was justice enough.

Every time Gregory came into the house, he was drunk or high, and he would constantly bring up my night with Brad. I was truly sorry for what I had done but he never let me forget it. We argued relentlessly, him always calling me a "whore." He called me a "whore" and "slut" in front of the boys, and even went as far as telling twelve-year-old Randy, "Your mother fucked another man." Randy's bewildered face still flashes through my mind. He lost respect for me until he was old enough to understand all the circumstances. I'll never forget his raging tears and pleading words, "Did you Mom, did you do that?"

I struggled my way down the path that led me back to the one shred of peace I had in my life, God. I had asked for His forgiveness but had never forgiven myself. I knew Gregory would never truly forgive me, nor let me forget. I began to pray daily, sometimes spending hours on my knees, at times falling asleep kneeling beside my bed, my face crusted with tears, my head ready to explode.

I had a supernatural experience during this time that is forever engraved in my mind. I prayed with fierceness for Gregory's soul, his very life. The drugs and cross-dressing controlled his entire being. I became aware of a nightly presence in our bedroom. I would wake up seeing a dark form across the room. It was small and didn't seem to have a shape, just emitted a sense of its being there. I always had the feeling of impending doom. I spoke with my pastor about it and he advised me to continue to pray, and stay near to God.

This phenomenon went on for at least a week, with the form continuing to get closer and larger until it finally appeared to be

sitting on the end of the bed, always on Gregory's side. I was afraid for his life because he had told me years earlier, that when he was a heroine junkie, there had been a time when he had literally sold his soul for drugs. He had made a pact with the devil and was never without drugs from that point on, even when he had no money. I believed the devil owned him and had come to collect the contract he had on his life.

After a week of being awakened every night by this eerie *thing,* I awoke one night to see what appeared to be a black hooded form, at least as tall as the eight-foot ceiling, and half as wide across the shoulder area. I could not see a face but I knew it was the angel of death, the Grim Reaper. I knew I was not dreaming. I sat up in bed, terrified. The street light cast enough light into the room so I could clearly see what was around me. I literally dug my fingernails into my leg; I was awake! This apparition stood on Gregory's side of the bed, no longer at the foot of the bed, right at his head!

The fear coursing through me felt like an iron fist had plunged in and tried to pull my heart out. I have never felt such pure terror. When I told my pastor about it the next day, he believed I saw something evil, and that Gregory's life was indeed in grave danger. I prayed more fervently and the very next night, just before dawn, I was awakened by a brilliant light in the bedroom. When I opened my eyes, I saw what I believe was an angel from God. She stood on Gregory's side of the bed, at his head, in the same position as the hooded form the night before. She was as tall and as broad, but a wing was outstretched over Gregory in a protective gesture. There was a golden glow of incandescence, with a softness that might have felt like baby powder, had I been able to touch it.

At that moment, I felt a peace come over me like I had never felt before, and would never feel again. Besides my pastor, it took some time for me to tell anyone about the nightly visitors, until I felt comfortable with the fact that I had seen a messenger from God. That peace would fade away as my tormentor sank deeper and deeper into the realms of the drug world.

BATTLE GROUNDS

My best friend Danielle moved a thousand miles away. I was nearly devastated and realized I would have to live my miserable life alone again, with no moral support. I was heart sick and depressed for many months. When we lost touch, Gregory tried to discredit our friendship by saying, "I will always be the only true friend you will ever have, I will NEVER leave you." The teeth of sarcasm bit into my heart, leaving a decaying wound.

Gregory started talking about cutting me into tiny pieces if I ever left him. He said he would never let me be happy with another man. He said, "I'll let you find someone and wait until you're happy, then kill him in front of you." I believed he was demented enough to do it. He was sick, and I was afraid. I never let him know how afraid I really was. My guard was never down. I always stood up to him, but never stood up for myself. He wasn't physically abusive but I was an emotional prisoner who was being psychologically raped almost every day of my life.

After one of our fights, Gregory destroyed a gift he had bought me two years earlier. It was a painting of a blond-haired girl sitting in a meadow of daisies. She was a beautiful rendition of the daughter I would never have. Instead of a birthday card, he had given me a "Congratulations on a baby girl" card. It had been one of those rare moments when he made me feel special. The painting was only a material object but *she* was symbolic of the one thing that had a

special place in my heart, my little girl. I was incredibly stunned when I found Gregory had viciously slashed the painting with a knife. *What kind of psychopathic animal lurked inside of him?*

It was February, and I ran from the house with bare feet in the middle of an ice storm, with temperatures plummeted to below zero. I just wanted to die. I ran down the road until I could not go any further. Gregory found me lying beside the road, nearly frozen. He picked me up, carried me back home, and bathed me with warm water. I wished he had let me die.

On another occasion, I tried leaving the house, to get away from him after an argument. He took the car keys, so I walked out, without having any real sense of where I was going. I walked nearly five miles, and as I got closer to my Dad's house, I knew I had to tell him everything I was going through. I had an eighth of a mile to go, when Gregory came around the corner in the car. I heard him coming, and as he accelerated, I realized he was going to run me down. I screamed and spun around to face my executioner, willing to sacrifice my life for the peace of death, when I saw he had Matthew and Caleb with him. He stopped within inches of me and sat there laughing, with a hideous look of satisfaction on his face when he realized, I was showing my fear. He said, "Did you think I was going to hit you? Where are you going, to tell your Dad?" He knew me. He was me.

I tried for over an hour to move, and every time I did, he drove the car in front of me to block the way. I wished I was dead. I stood motionless, staring at an inanimate object, wishing I could fly away into oblivion. I was so close to my Dad's, but hopelessly far away. I was tired of fighting and wanted to go to sleep, and never wake up. The boys were pleading with me to get in the car and come home. I did. He won.

Many times I was driven to the point of banging my head against the wall as hard as I could. I wanted him out of my head. I wanted to crack my head open and spill his guts onto the floor. I wanted him dead. I wanted to die. The stress level in my life was maxed out. I lost weight, something I couldn't afford to do. At only 115 pounds, I dropped to 97. When my voice became hoarse and stayed that way

for several months, I went to an ear/nose/throat specialist. I had developed a callous on my voice box from all the yelling and screaming. I had to have it surgically removed and rest my voice for five weeks. I was instructed not to talk at all, not even whisper. I had to write notes to communicate with the boys, which was very hard for me. I was in the habit of telling them every day, "I love you." That was the only time I did not say it to them every day, which I still do today.

I finally filed for divorce again, for the third time, and again he persuaded me not to end the marriage, by doing and saying everything I wanted to see and hear. He reminded me of my religious beliefs, and I did not want to disappoint God again. He took Bible studies and joined my church, but the deception was again brief.

During one of our endless fights, I threw all his belongings outside. He started throwing my clothes and personal papers out of my desk. My poetry and short stories I had written were strewn all over the front lawn. When he came in the house I slammed him up against the wall and screamed into his face, "I want to kill you." I knew by the look on his face that he believed me. He finally left and I picked up the mess.

Because of the fighting, and the sheriff having to be called several times, I received notice that I could no longer live in the housing project. I had one month to find a new place to live. We found a house to rent, again outside of town, and we moved once again, for the third time in as many years.

In 1988 Randy decided, at fourteen, he wanted to go live with his Dad. He hated Gregory, resented me, didn't want to go to family counseling or church anymore, and was sick of the screaming and fighting. Gregory disciplined harshly and I never tried to differ with him. There were times, when Randy was younger, that he didn't want to eat his vegetables, and Gregory would make him eat them until he vomited them back onto his plate, and then he would make him eat that. If I disciplined Randy, I used a belt, and he hated me for it. Randy told me he didn't want to live with me anymore, that I always chose Gregory over him, my own son. It broke my heart to

let him go, but I knew he was so right, so wise, and so much stronger than me.

My life continued to be a circus, and because Gregory would eventually wear all of my clothing, I began to compulsively buy clothes for myself. I would shop at the Goodwill Store or buy things at garage sales. I would only wear something once, knowing he would try it on when I wasn't around. I never knew when he dressed in my clothing. A lot of times he would have my things on under his clothing and I didn't know until it was time to do laundry. I asked him why he didn't just buy women's clothing for himself. He said, "I don't want my own things, I want to wear yours." He needed to feel in control of me in order to feed his obsession. Visions of him in my clothing filled my thoughts, mocking me. I hated this loathsome creature I was bound to, with a chain that I lugged behind me every day of my life.

I eventually told my pastor about the cross-dressing side of Gregory's life. Up to this point, he only knew about the drug abuse. He strongly advised that I not give in to any of his demands, and absolutely refuse to be a part of his perverse ways. The real battle began when Gregory knew he was losing his domination of me.

I was watching the *Oprah Show* one day when someone mentioned cross-dressing. I wrote Oprah a letter, telling her about my life with a cross-dresser. About a year later, I received a phone call from one of the show's producers. Oprah wanted Gregory and me to be on her show about "secrets." When I told the woman there was no way Gregory would ever agree to be on national television, she called a second time, saying that Oprah had agreed to do us in "shadow."

I told Gregory about it and he wondered how on earth Oprah had found out about him. I told him I had written her a letter and he wasn't even upset with me. He thought about being on the show, and I was surprised when he agreed to do it, but our chance was gone when the woman called again to say there was no available flight, or an airport close enough to get us there in time for the taping. It was an honor to be considered for the *Oprah Show* and I told several people about it, but couldn't tell them what the show was about.

ALMOST OVER

The last two years of my marriage was like living in the eye of a storm that couldn't decide when to hit. Gregory was losing his grip on me as he saw me becoming stronger than him. He was watching me struggle my way out of a cocoon and becoming a free butterfly. I believed he anticipated my leaving for the final time, and concluding a long sad chapter in my life. A chapter, which would ultimately be absorbed with ten years of chaos.

He sank into deep periods of depression. For days he sat in a chair and would do nothing but drink coffee, watch television, and leaf through women's magazines. For endless hours he would look at pictures of lingerie. He would clip promotional coupons for free panties and pantyhose. I would find them in my desk or my purse, him expecting me to mail them. I threw them in the garbage and wished I could do the same thing with him. Whenever I came in with the mail, he would always ask the same question, "Did I get anything?" I knew what he meant. He would ask, "Didn't you send for my things?" I ignored him and his hints.

I tried talking him into getting special tests done to see if he had a hormone imbalance, something that could be corrected with medication. He refused. I tried talking him into hypnosis, thinking that if he could get at the root of his problems, he could defeat them.

He refused. I found a specialist who counseled men with this particular problem. He was willing to travel a hundred miles to help Gregory. He refused. I did everything humanly possible to save the man and the marriage. He refused to let me.

Gregory slept all day and became a nocturnal snake with his friends, staying out all night getting high. He'd come home at three and four o'clock in the morning and start slithering in and out of the bedroom, taking my clothes into the living room to dress up. I pretended to be asleep when he'd sneak into the bedroom. He would stand beside the bed, hovering over me. If I was asleep, and he did wake me up, I knew what he wanted. I refused. He'd say, "I'll just wait until you fall asleep, then I'll get what I want, maybe I'll just tie you up."

I would force myself to stay awake, fearing he would do it. When daylight came, seeming to bring safety with it, I slept. Sometimes I would fall into a deep exhausted sleep, and always, he would arouse me until I would wake up, not being able to, or wanting, to say no. My mind was screaming *no* but my body was imploring him to continue. My body was his victim and my mind was being violated in an inhuman way, or was it the other way around? I was pathetic. I thought I loved him. I knew I hated him. Some nights I would sleep upstairs with the boys. I knew I was safe. He did not want them to find out about him. He learned to leave me alone.

One night when I got up to go to the bathroom, Gregory was in the living room, dressed up, wearing my favorite dress. He had make-up on and his hair combed in a woman's style. I nearly choked on the bile that came to the back of my throat. He said, "Do you think I'm pretty? Don't you think I look better in your dress than you do? I know you like it; I know you want to make love to me." He wanted me to look at him, and take pictures of him. I sat in a chair with my eyes closed, with an urgent premonition not to allow myself to fall asleep, while he paraded throughout the house until morning.

My brother Rob's wife called me around 11 o'clock in the morning, wanting me to go shopping with her. When I told her I could not leave because Gregory would not give me the keys to the

car, she sensed something was wrong. She knew I was crying. The next time I talked to her alone, she asked, "What is he doing to you?" I told her everything, making her promise not to tell Rob, but she did anyway. They urged me to leave him, and Rob wanted to kill him for what he was doing to me. He wanted to be my protector again. They knew there had been problems with drugs all through my marriage, but never dreamed I was living with such a twisted form of agony and abuse. My sister-in-law said, "If you stay, you must like it."

She had survived an abusive relationship herself. She empathized with me but she was a stronger person, she couldn't feel how trapped I felt, or maybe she did, and was trying to jolt me into action. I was a non-person. I was nothing. He had worn me down to the lowest level of existence, and I struggled every day to stay afloat in a cesspool that was toxic enough to kill me. I wanted to succumb to the vapors and sink into my grave, where it would finally be over with.

Gregory decided to go to a truck-driving school in Wisconsin, a five-week "crash course." When he got home, he tried to get on with a local man who owned a fleet of trucks. They decided to put him in a truck with one of their drivers, a man named Mark. On the night he was supposed to leave, Mark called the house for him but Gregory was nowhere to be found. I assumed he was out with his drug buddies. Mark had a deep sexy voice and I found myself talking to him. He made me laugh, something I hadn't done in years. I wondered what it would be like to meet him and get to know him.

My old pattern surfaced of ending one relationship by getting into another one. He sounded interesting and I told him that when I was sixteen, it was a fantasy of mine to run off with a truck driver and see the world. He said, "Maybe I can fulfill your fantasy." I told him I was not happy with my husband, and that we had had problems for the whole ten years we'd been together. He was so easy to talk to. I had no idea what he looked like or who he was, only that he was a local man, but I wanted to meet him.

It was two months later, during another argument, when I slammed out the door screaming, "You're a pervert, a fucking pervert!" The words screamed their way up my throat until they escaped my mouth

in hysterical gasps. The adrenaline was pumping through me so fast my words were echoing inside me, bouncing off the sides of my head. I knew I hated and feared him enough to kill him. I knew if I didn't get out of the house, one of us would die.

I went to the neighbors' to get the boys, and get a ride to Rob's. When Gregory called two days later to see when I was coming home, the somberness in my voice made it painfully realistic to him, I was NOT coming home. The raging tempest was over. My decision was cemented into finality. I was strong enough to be indifferent, and now freedom could be mine.

When I slammed the door behind me, I knew I was never coming back. I had made the decisive decision months earlier, if I ever left again, it would be FINAL. I took the first step toward freedom from the man I hated as passionately as I had loved him. I also knew my misery would not be complete, until he said it was.

THE STALKER

I made arrangements with my landlord. I knew that Gregory would not be able to pay the rent. He agreed to tell him to get out when the rent came due. Jeremy stayed with his Dad, and Matthew, Caleb, and I stayed at Rob's. After three weeks Gregory moved to his parent's house and the boys and I moved back to our house. I wasn't denying him the right to see the boys, but he was trying to use them against me. They always told him, "We won't talk about mom." I always dropped them off at his parents whenever he wanted to see them, I did not let him come to the house. One day he had them and he came out to the house, drove up to my bedroom window, and told the boys, "I know your mom's in there having sex." Matthew was eight and Caleb five, certainly not old enough to understand the meaning of that.

He started calling me at all hours of the day and night. If it didn't concern the boys, I hung up. The phone rang constantly, nearly around the clock. He would either threaten me or just say nothing at all. He would make crude comments like, "No man will want you with your floppy tits and popping pussy." Words were the only weapon he had left, and he was desperate. His words would cut me to the quick.

He stalked me for weeks. Every time I went somewhere, he was there, lurking around corners or behind buildings. He warned me

not to be happy with any man, I would *always* be his. He threatened to burn the house down with me and the boys in it. He talked about killing all of us, and then himself. I really didn't think for a minute that he would ever hurt one of the boys. It was just his way of intimidating me. Never the less, I didn't take any chances. He was ready to snap and I would die to protect my boys' lives.

I was in no financial position to file for a divorce. Lawyers wanted $700.00 up front. I had already borrowed from my family in filing for the previous divorces I had cancelled. I couldn't go to them again. I had talked to the police but there was nothing they could do until I filed papers. They could not even issue a restraining order. This was before all the new stalking laws were on the books.

I started keeping a log of all the phone calls and encounters. I kept track of dates, times, and each incident, word for word. I knew I had to have some proof if something did happen. At one point I was receiving over fifty phone calls a day, either threats or hang-ups. I came home one day to find his sunglasses on the kitchen table. The sunglasses on the bare table were his message; he could take me whenever he wanted to. I had changed all the locks, there was no way for him to get in, but he had been there. I frantically checked all the windows and doors for forced entry. He had gotten in through an upstairs bathroom window. I had left it open to air out the room. He had cut through the screen and crawled through.

I called the police, there was still nothing they could do, other than advise me to move into town where I was not so vulnerable. I refused to let Gregory influence my thinking or control my actions any longer. He had done it for ten years. The officer warned me to be especially careful during the full moon. He believed in the "lunar pull" and tried to make a joke about "lunatics."

The police were on alert because they knew how explosive the situation might be. One of the worst calls they can receive is one with domestic violence. My house was in a remote location outside of town, not visible to the closest neighbor. They were aware that if Gregory cut the phone lines, it could be impossible for me to get out of the house safely. The boys and I devised a plan for Jeremy to go

out an upstairs window if I yelled during the night. My landlord made a rope ladder for me that attached to a window, and could be thrown down from the inside.

I spent many sleepless nights, my ears pricking at the least little noise. I had a Doberman, but she knew Gregory. She might not be any protection, but she would alert me to noise. I lived with the dreadful feeling of waking up to Gregory standing over me. I kept a heavy lead pipe on the floor beside the bed. I thought about getting a gun but didn't want to take the chance of one of the boys getting hold of it. When I did sleep, I had nightmares that would reach into the dark recesses of my sleep and drag me into a dimension of terror, until I awakened with a jolt, not knowing if it was finally happening, *I was going to die.*

Once I dreamt I was sitting in a car, holding a baby. A man approached the car and I stared straight ahead, afraid to look at him, but knowing what he would look like. His face was pale white, almost ashen, with sunken cheeks, and deep-set hollow eyes. He looked like a skeleton, like death. I felt something hot being poured on my cheek, and as I looked into his horrible face, he whispered in a satanic voice, "Mother, mother, mother, you're gonna die." It was then that I realized the man in my dream was urinating on me.

One night I opened the back door to let the dog out, and there in the newly fallen snow, were footprints. They were by the backdoor, the kitchen window, and in the driveway. I knew Gregory had been there, trying to get in, looking in the window at me as I lay on the couch watching television. How long had he been there watching me? It was a full moon, and I did not sleep at all that night. The next day I found where he had parked down the road, walked across a field, came through the yard to the living room window, circled the house to the back door, kitchen window, and out the driveway. I called the police, still nothing.

I was able to file for a divorce four months later, when I convinced a legal-aide attorney, with the help of my counselor and the police, that my life was in danger and I was in serious need of financial help for a divorce. The judge immediately issued a restraining order, which

included any harassing phone calls. Gregory had gotten a job driving a semi, but continued to call even when he was out of town or out of state.

My attorney filed charges against him for breaking the restraining order. I had gotten a new job, ironically selling lingerie through home parties, and did not want to change my phone number. I finally went through the inconvenience of doing so and had to contact all my customers of the change.

When we ultimately went to court, I brought my log of all the calls he was pounding me with. Two of the long distance calls had shown up on my telephone bill as collect calls. He must have walked away from a phone booth without paying, and the operator reversed the charges. The times noted on my bill matched the log I was keeping, within a few seconds. Also noted were the locations called from.

The judge told Gregory that he could very easily request copies of his logbooks, which would put him in the same locations as the phone bills record. It would not be hard to prove that he had made the calls. The judge told Gregory that he did not want to jeopardize his new job, but he warned him that if the calls persisted, and he didn't leave me alone so I could get some sleep, he would slap him with a contempt charge, throw him in jail, and take his visitation rights away. The harassment ceased.

In due time, Gregory moved to another state. He calmed down once he got on with his life. I finally gave him my phone number again, so he could call Matthew and Caleb. I got a call one day from a woman he was living with. She wanted to know if there was anything about Gregory she should know. She was in love with him and planned to marry him. I told her the ugly truth. The last thing she said to me was, "I just want to understand him, and try to help him...."
I didn't even wish her good luck.

THIRD TIME IS THE CHARM

After my life calmed down I was able to enjoy my new job. It was fun doing the home parties for the lingerie company I worked for. It took a great deal of work, with the planning of parties, lining up girls to model select items, drumming up customers, planning the parties, taking the orders, and delivering. I loaded and unloaded my car with supplies and sample merchandise, trying to stay in a fifty-mile radius. I usually did five parties a week. I made a nice profit and was hopefully on my way to independence and being off welfare. It seemed like I was always on the go. The boys were all into sports programs at school, so that kept me busy as well.

I thought the stress had caught up with me when I started having severe abdominal pain. I had had heavy periods in the past, but it was much worse now. I went to my family doctor and after running some tests and doing an ultra-sound, I learned I had endometriosis and my uterus was tipped and three times larger than normal. Verdict: a complete hysterectomy. I was still on a medical card so I wasn't worried about the expense of the surgery. It was necessary to my health, but I hated the thought of having a long recuperation. I had the surgery and stayed at Rob's for a while so I'd have help. I healed fast and it wasn't long before I felt like a new person. No more pain or stress as I knew it.

Christmas was coming up and I decided to send Mark, the truck-driver, a card. I knew he was interested in me, and I wanted to get to know him. I longed for a man who would treat me good. All I wanted was to be in a happy relationship, and share my life with someone decent. He called me two days later and I was pleasantly surprised. He wondered what happened to me. He had tried calling almost every day for three weeks and thought I had moved away. Finally he gave up when someone had told him I had taken Gregory back. When he got my Christmas card in the mail, *he* was pleasantly surprised. I told him about my surgery and that I had been staying at my brother's house, and that I had definitely NOT taken Gregory back.

Mark was getting ready to leave on a road trip and said he'd call me again. He called the next time he was home and we started seeing each other. He was usually gone on the road for three to five weeks at a time, and then home for a week. He seemed like a nice guy and I thought handsome, but he was shorter than me, which was okay, I had just always preferred taller men. He was exciting to me. He drove a semi and always had so many stories to tell about being on the road. He had a Harley and was what I considered a rebel, and I needed that strength in my life.

When he asked me to go on a short road trip with him, I was thrilled! It was a whole new experience, seeing the country from a big rig. I had never been anywhere. I started going on short trips, then went for a week or two at a time. I'd have a friend stay at the house with the boys, and they thought it was neat getting a postcard from all the states we went through. I would call home and tell them where we were and what I'd seen. I took lots of pictures to show them when I got home. It was truly an awesome experience.

I met his family. His mother and grandmother lived together, next door was his aunt, and just down the road was his sister who had lost her husband to cancer the year before. Across the street from her was his brother. I was impressed by the way he treated his family, especially his mother and grandmother. They were all very close and looked out for each other. He visited with all of them whenever he was home. Home was a trailer he shared with his son, who was

seventeen. He was under the supervision of an uncle when Mark was away.

I really enjoyed spending time with Mark. We got to know each other fast. We talked about our lives. He had been married twice and had a son and daughter with his first wife, a son with his second wife, and a son with a woman he had lived with. He didn't tell me about the youngest one right away, maybe the subject never got that far, or maybe he thought it was too much information, too soon. When I did find out, it was because the Friend of the Court from another county was after him for owing thousands of dollars in child support, to three different women. The red flags were flying again, and again I ignored them.

We took a ride on his Harley one day and were stopped by the state police and he was arrested. Luckily my brother Rob and his wife were with us, so Rob drove Mark's bike home for him. His mother bailed him out of jail. We found out later that his ex-wife had called in on a warrant when she was visiting with her brother, which was Mark's best friend.

His mother and I went to court with him, and he was allowed to see his nine-year-old son, whom he hadn't seen for seven years. He was a wonderful little boy, very polite, and he looked just like Mark. His face glowed when he finally was able to see his daddy, but he was reserved, not knowing him. I didn't agree or disagree with his lack of responsibility. It really wasn't any of my business. I respected the way his mother and grandmother rallied around him, but I couldn't deny the fact that he was shirking his fatherly duties. My own sons had deadbeat daddies; I knew where the women were coming from, no matter how many excuses he had. He thought it was easier to ignore his responsibilities, but in so doing, he was depriving his son of a father.

None of this changed how I felt about Mark. By this time we were in a committed relationship, at least he was the only man I was spending any time with, both sexually and emotionally. I can't say I ever really fell in love with him, but I gradually began to love him. There is a distinct difference between being in love and loving

someone. He was the first to actually say, "I love you." I blurted that I loved him too, before I knew what my mouth had said.

He treated me okay. He was rough around the edges, kept his emotions under a shell, didn't reveal deep thoughts, but he made me laugh, something I didn't do enough of. He believed it was dangerous to let other people know how much he cared about someone. It meant he had a weakness, and they would know his weakness, and use it against him.

He drank, a little more than I wanted him to, but he didn't drink while he was on the road. When he was home, it was his way of unwinding. He had trouble knowing when he'd had enough, and he got intoxicated easily if he didn't eat before he drank. When he drank, he was loud, rowdy and argumentative, and a little embarrassing. He always thought he was right and I learned to agree with him, it was easier, and I refused to argue.

He did teach me to become stronger, not to take any shit from anyone, to stand up for myself. I learned fast, and that became a good thing for me. I knew I had to share him with his family, and every time he came home, there were ten people calling him with something they needed his help with. I never said anything, but started to realize that he put everyone else before me. When he was finished doing everyone a favor, working on cars, cutting wood, building houses, you name it, it was time for him to go back on the road, and there was no time for me. All the projects we wanted to do never got done. He always wanted to drag me out to the bar with him and I was never interested in sitting there for as long as he wanted to. I still sat home and kept to myself and he just went off and did his own thing most of the time. My life wasn't perfect, just okay.

A TOUCH OF HEATHER

Mark's daughter still lived with her mother. When she was fifteen, after three years of rebellious behavior, she wanted to come and live with Mark. Mark's home was the open road and the sleeper of a truck. I never hesitated, I told him to bring her to me.

I shifted the boys around in the upstairs bedrooms so Hannah could have her own room. The day Mark brought her to my house was my God send. She came in with a big smile, blue eyes, and long blonde hair, the girl in the painting Gregory had slashed. All 85 pounds and 62 inches of her rushed into my arms with a big hug, and I became the proud mother of a beautiful daughter. It didn't take long for us to become close friends, and I love her as if I had given birth to her. All the boys loved her, a balance in their rambunctious lives. She was like heather, the hardy evergreen shrub with pinkish flowers. She was hardy, bold, and street wise, but she was also delicate, with a sensitive heart.

I laid out the rules for her, which weren't many. She had no problem with a 9 o'clock curfew on school nights and 11 o'clock on weekends. She was very mature for her age and always considerate enough to check in, or call if she was going to be late. She made friends at school easily, and it wasn't long before the new girl was very popular, and my house was full of teenagers. She didn't start

dating right away, but had a lot of guy friends. She took auto mechanics class at school and was the only girl, but she fit right in with all the guys.

She confided in me, asked for advice, and took it. We felt comfortable with each other almost immediately. It didn't take long before she was calling me mom. It was so different for me to have a daughter, an enhancement to my four sons. We talked about her achievements, her problems she had encountered with previous boyfriends, her relationship with her mother, how she felt when her parents had divorced, and her stepfather. She shared my love for writing and I read some of her poetry, and she mine. She was such a breath of fresh air, and still is very much a part of my life. We became such good friends.

When she turned sixteen, Mark bought her a used car. She had saved some of the money and he put in the rest. She was so excited when we went to look for a car. They finally settled on a Yugo because of the gas mileage it got, knowing she would be running the wheels off it.

Hannah started dating Grant about six months after she came to live with me. He is 6 feet 4, 250 pounds, and they looked like "Mutt and Jeff" together. They were inseparable and argued as much as they laughed together. I called him "Baby Huey." He would carry her around like a little rag doll, they were so cute together. They would break up but always get back together, remaining friends even when they weren't dating. I thought they would be together forever. They did end up married (now divorced), and made me the proud "Grammy" of a boy and a girl.

Mark and I would eventually decide to buy a house in town, and Hannah and I went looking. We found a five-bedroom house, and we both fell in love with it, and all the possibilities it had. It was listed through a real estate broker, so we waited for the contract to run out. I then contacted the owners, asking for a rent-to-own option. I wrote them and put my proposal on paper and a month later, they contacted me and accepted the offer. We were thrilled and couldn't wait to move.

FROM BAD TO WORSE

I don't really know when it went from good to bad, or bad to worse. It was a gradual thing and I just accepted my life the way it was, thinking I would never really have life the way I thought I deserved. The funny thing about life, it only comes one day at a time. We can't foresee the future and we can't change the past. Nothing could be as bad as I had already been through. I could handle my life such as it was.

I went for a job interview and was so sure I was going to get the job. Mark promised if I got it, he would buy me a car. I got the job and he bought me a used Camaro. It was a beautiful and fast car. It only had one owner and they had taken good care of it. His brother did custom paint jobs and he planned to paint it, put big tires on it, and put "Color Me Gone" on the back of it. He always talked such big dreams for me. Three months later, the engine blew, and the car sat in the back yard, the graveyard for the car.

Mark and I talked about marriage and one night he came home off the road and went straight to the bar. He called and wanted me to come down but I was tired, I was going to bed. Hannah walked down to the bar which was just a few doors down from us. She tried to explain to him that I was tired and didn't want to come down. She knew he wanted to propose to me and he was afraid I'd say no. She

tried to tell him to just wait until the next day, when he wasn't drinking.

He came home about three hours later, drunk. I heard him come in and he walked into the bedroom and asked me why I hadn't come down to the bar. I told him I was tired and didn't feel like sitting there. My back was to him and all of a sudden I felt something hard hit my head. He yelled, "Well here, this is yours." I realized he had thrown something at me and it had bounced off my head and hit the wall, ending up on the floor. He left. I got up after he slammed the door and found lying on the floor what had bounced off my head. It was a box from a jeweler. I found the ring on the floor, one he had special made. It was a Black Hills gold ring, with two leafs and a diamond in the middle. He had chosen the diamond himself and it was small but was close to being flawless.

I was stunned. Not because of the beauty of the ring, but because of the fact that he had thrown it at me, bouncing it off my head, with as much feeling as a robot. I was crying when Hannah came in. I told her what he had done and she was as mad as I was. I refused to put the ring on my finger. I never said a word about it when Mark came home the next day after spending the night at his mother's house. He never offered an apology, of course it was my fault for refusing to come down to the bar. "I'm sorry" were two words that were NOT in his vocabulary.

About a month later, I got over it, deciding that I would marry him. My poor judgment does not lack any stupidity. What is that saying about ignorance is bliss? Grant and Hannah were married on November 29, 1992, and Mark and I were married a month later.

The gradualness of the abuse was a restrained degree of disrespect. Mark called me a "little bitch." Maybe the reference was his term of endearment but it changed from a joking innuendo to a significant slam to my femininity. I didn't like it but I ignored and tolerated it. It was worse when he drank. He became aggressive with intoxication. It changed into anger at little things that would result in him throwing a glass at me, just missing my face, and smashing into pieces against the wall. It progressed to him throwing a marble top end table at me.

I pulled my legs up to block it and it hit across my shins. It came to him dragging me out of the house one night, pushing me into his truck and driving to a man's house that was responsible for hitting our dog with his vehicle.

Mark had been at his brothers' that afternoon and the dog was running in the road. The man came along and the dog ran out in front of him. He could not avoid hitting her. Mark was drunk and instead of listening to his brother trying to reason with him to take the dog to the vet, he got a gun and shot her in the head, placing the blame for her death on the man that ran her over. I learned later from his brother that the dog was only in shock, and very easily could have survived, had he taken her to the vet. I started to think of him in a different light, as a *bastard*.

His sister-in-law started having an affair and Mark found out about it. He came home off the road one night and we took a ride. We pulled into the driveway right behind his brother's wife and the man she was allegedly having an affair with. I followed his sister-in-law upstairs to her apartment and Mark stayed outside with the man. I thought he was just going to confront him with the rumors of an affair, and run him off.

Minutes later, Mark came up to the apartment and we visited with his sister-in-law for a while. I could sense that she wondered where her companion had gone to, but she didn't want to ask.

She had asked me when I followed her up, "What is Mark doing?"

I had said, "I don't know." After we left, Mark told me what he'd done.

He had confronted the man alright, with a pistol he had concealed in his boot without my knowledge. He told me he had grabbed hold of him, threw him to the ground, and asked him what was going on between him and his brother's wife. The man had denied any allegation, saying they were just friends.

Mark didn't feel that his sister-in-law needed any male friends while his brother worked out of town. He then proceeded to take the pistol out, shove it into the man's mouth, and ask him if he was going to stay away from his sister-in-law. Anyone in that position is

not going to be a fool. Mark then pulled the trigger; the man begging him probably pissed himself when he heard the click of the hammer. The gun was not loaded.

A police officer came to the house the next day, asking questions of both me and Mark. Mark denied having done what was reported to them. I lied to the officer, not to protect Mark but because I didn't want to be involved. I told him I didn't know what happened. What I did know was only hearsay anyway, I hadn't seen anything. The officer believed Mark and left. I came to know the violent streak in Mark's character, a bit more personally then I wanted to accept.

I knew there had been times in Mark's past when he'd been violent. He had been abusive with Hannah's mother, and also the other woman he'd been married to. It didn't matter what the women had or hadn't done, they didn't deserve to be abused, but Mark excused his behavior as warranted.

I knew for months that the odds of our relationship lasting were slim to none. I was sitting on a ticking bomb and could only hope it didn't detonate when I was near it. I walked on eggshells. When Mark was sober, he was really an alright guy, but his drinking was a part of him he would never give up.

A SECRET EXHUMED

I hadn't seen any of my relations on Mama's side of the family in years, so when a reunion was planned, Mark and I decided to go. Dad would ride with us and we planned to meet Mary and her husband there. We booked rooms at a motel, planning to stay the weekend. The reunion picnic was held at my aunt's house and I loved visiting with my grandmother, whom I hadn't seen in years. Some of the aunts, uncles, and cousins I hadn't seen since I was a child were there.

After a day of visiting, Mark, Dad, and I returned to the motel and decided to have a drink in the lounge. My Dad had been disturbed at the reunion and I sensed tension between him and the uncle who was always my favorite, Mama's brother. I asked him about it while we were sitting over drinks. He said, "That son of a bitch, I hate him." Wow, that was not like Dad to express hatred for anyone. I always thought he liked my uncle but I felt the hatred seething from my Dad. He had enough drinks in him that he decided to confide a family secret with me. He said, "I shouldn't even tell you, you'll say something to someone."

Dad was getting more agitated and pounding his fist on the table. I could tell he was struggling, holding something in when I saw tears

in his eyes. I wondered what could be so terrible to make Dad react like this. I said, "Dad, you can tell me, I won't say anything." (I'm sorry Dad, but this needs to be in the open, and after eight years of silence, I'm going to break my promise.) The consistency with the snags in the thread will not be a complete story unless I remove a shovel of dirt from Mama's grave and reveal her secret. All the snags have to be unraveled. If I'm not honest, the elusive piece in the puzzle will remain lost.

Mama was very young when Dad married her. She was pure, virginal, and Dad loved her with all his heart. He knew he was going to be her first. On their wedding night he promised to be gentle with her. He would never do anything to hurt her. He promised to make her first time special for her. He was shocked to discover she was not a virgin. He was enraged. She had told him she was a virgin. Tearfully she told him about her brother. When she was twelve, he raped her, not once, but repeatedly over several years. He would hold her down and smash her head into the floor to make her submissive. Mama's simple words to me as a child echoed, "You can't do that."

During this time is when her convulsions started, she developed epilepsy. The terrible condition that Mama carried with her for the rest of her life, until it killed her, was a result of the vicious attacks from her own brother, a savage beast. Dad wanted to return to where her brother lived and beat him to within an inch of his life. Mama intervened and Dad let it rest. They never returned to Mama's hometown during their marriage. He carried the deep-seated hatred with him, never telling anyone the horrific family secret, until he revealed it to me.

I don't know if any of Mama's family members ever knew what had happened to the delicate girl that lost her innocence at the hands of a sibling. If they knew, they kept it a dark secret, until now. Now, I can wonder, is the faceless molester in my subconscious mind the very same man that would become my favorite uncle? If he committed an unforgivable sin against his own sister, would he touch another innocent little girl? I will never know.

One of the most difficult things about being an adult is having to change my perspective of how I viewed things as a child. My once favorite uncle is a monster and I now share the hatred for him that Dad has.

WARNING SIGNS

Back tracking to when Matthew was nine, we were still at the house in the country. He started acting up around the time I was going through the separation from his Dad, and starting to date Mark. He was unruly, sassy, and was misbehaving in school. I was getting calls from his teacher. He couldn't seem to sit still, keep his mouth shut, and get his work done. He was bothering the kids around him. I finally suggested that his teacher set him off by himself and it seemed to work. At home, he was pouty, and it seemed like he was always doing something wrong to get my attention. I've always been able to communicate with my boys. We have always been open and honest, and I tried never to say more than they wanted to know. I never talked negative about their perspective fathers, even though we had our own problems. I wanted them to know they had good fathers.

With Gregory being so far away, I tried to make up for the lack of a father figure by letting Matthew and Caleb spend some weekends with Gregory's parents. Gregory had two younger brothers, Pete was only seven years older than Matthew, and Steve was already out of high school and working, but living at home. Pete was always giving Matthew something— a fishing pole, a radio, money. He was a spoiled kid who got whatever he wanted, giving things to Matthew when he got tired of it. The boys enjoyed going and they would talk

about playing video games, going fishing, swimming in the pool, and riding four-wheelers at camp with their uncles.

I thought his bad behavior was due to the divorce. I was seeing Mark, and he didn't hear from his Dad as often as he liked to. One day he was playing across the road in a field. Caleb, who was six, and a neighbor boy were with him. I didn't know what they were doing until I looked out the window and saw Matthew running across the road with a pail of water. I went outside and saw smoke billowing up in the woods, from the direction he was running to. I hollered to stop him and he started crying, "I started a fire!"

I ran into the house to call the fire department only to discover that someone on my telephone party line had left their phone off the hook. By this time all the boys were out of the field and standing on the road. I got in the car and raced down the road to a volunteer fireman's house and he called it in for me. When I went back home, Matthew, Caleb, and the neighbor boy were all crying and scared out of their minds.

The fire truck arrived in a matter of minutes and got the fire out, which by then had been raging toward a house. One fireman took the time to talk to all three boys and made sure they all understood the danger of their actions. Matthew's behavior had gone too far, but I couldn't put a finger on why he was acting the way he was. He told me it wasn't because of my seeing Mark, he liked him.

One day, after being at camp with his uncles, Matthew commented about Uncle Steve wanting to take unusual pictures of him and Caleb. Right away my inner voice told me to press the issue with him. When I asked what he meant by "unusual" pictures, he was a little vague, saying, "Just us doing different things." I asked him if his uncle had ever taken pictures of him and Caleb while they were naked. I knew they ran outside and dove in the snow or jumped in the river after taking a sauna, usually naked, it was a guy thing. Matthew said, "No." I thought it was unusual that he used the word "unusual."

I wasn't taking any chances. I put a stop to the boys going to camp with their uncles. When Steve wondered why, I told him what Matthew had said about him wanting to take "unusual" pictures of

them. He said, "What do you think, that I would molest my own nephews?" He never really addressed what he knew I was thinking, was just very indignant with me for suggesting there was a possibility. I didn't care. I broke all ties with Gregory's family. The boys were upset and didn't understand why I was being so mean. It took them a couple months, but they finally calmed down. Life seemed normal again, but I lived within a bubble, waiting for it to burst.

The bubble would burst in January of 1995, when Matthew was fourteen years old. In one of our casual conversations, something came up about sexual abuse. I can't remember exactly the way the conversation went, but he suddenly became very quiet. I knew with a mother's instinct that someone had violated my son. I had to stay calm. I asked him, "Did anyone ever touch you in a bad way?"

His answer, "I don't know." I knew he wasn't going to just come out and tell me if something had happened to him. I sensitively had to ask the right questions, and hopefully he would answer truthfully.

I reminded him of when he used to go to camp with his uncles. I reminded him of when he told me about his Uncle Steve wanting to take unusual pictures of him and Caleb at camp. I asked, "Did Uncle Steve ever touch you?"

He answered, "Not him." I knew I was getting somewhere and I was apprehensive about learning the truth. My heart was pounding, in fear of hearing that truth.

I asked him if his Dad had ever touched him, thinking I would kill him if he had. Again, the answer was no. Matthew was getting uncomfortable, hanging his head in shame, and then he started crying. "I tried to tell you mom."

I said, "Who Matthew, who touched you?"

His story would break my heart into what felt like a million pieces. Knowing that what had been done was happening literally in the very next room, and went on for almost a year. Knowing I did not see any of the signs. Knowing that my son had been threatened and bribed into not telling what was happening to him. Knowing that I had been so entangled in my own messed up life that I did not protect my son from the most contemptible violation of his innocence.

Knowing that we now shared the same damaging circumstances, but his had so many more ill effects on his life. The worst scenario a parent can face was now in the open.

MAKE IT STOP

When Matthew told me what happened, I called the state police, and we went to the station so he could tell his story. I was sick with the revulsion of knowing that it was not his Uncle Steve, whom I'd suspected, but was instead his Uncle Pete, who had taken advantage of my son when Matthew was seven years old and Pete was fourteen.

Even before Gregory and I had separated, and we would visit his parents, the boys would be in the bedroom watching television or playing video games. They were never supervised. The thought never entered my mind that something could be going on. I always thought if anyone ever tried to touch one of the boys in an inappropriate manner, they would tell me. How wrong I was.

There was no reason on earth to think that something so hideous could be happening behind closed doors. It went on after Gregory and I split, and went on happening until the day I suspected the wrong person, and broke all ties with their family.

Everything Pete had ever given Matthew, the fishing pole, radio, money; everything was a bribe for his silence. The sick unspeakable act of Pete forcing Matthew to perform oral sex on him, ejaculating in his mouth and making him spit it out onto a towel. The thought of Pete making him perform this act all those times, while we sat in the next room. The thought of Pete, trying to get Matthew to perform

the same act on one of his friends. The thought of Pete and his friend, laughing about it. The thought of Matthew, a small immature boy, trying to "tell Mom" by acting up, and starting a fire in the woods. I felt so helplessly guilty for not protecting my son.

The officer took down all the information, and after questioning Pete, who was now nineteen years old, the prosecuting attorney could not, or would not do anything to mete out punishment that was so deserved. Pete admitted on a police report all of the facts that Matthew had revealed. Following is an actual letter, with excerpts, I received from the prosecutor.

"I have reviewed the above police report wherein it is established that Pete, when he was 14 years of age, caused your son Matthew*, to perform fellatio upon him numerous times in the late summer of 1989 at the....**

After our discussion of the case, including the potential legal problems created by the suspect's age at the time of the commission of the criminal acts, I conducted extensive research into the area of what court would have principle or primary jurisdiction in the case.

While there is some uncertainty in the interpretation of case law, it now appears that no court has proper jurisdiction over the 19-year-old suspect at this time! This is a very unsatisfactory conclusion to the problem and one which I am still exploring, however, I am not hopeful that Pete can be brought to court to answer for the offenses which he has admitted to.*

Probate Court has jurisdiction over a person who is now over 17 years of age at the time the charge is made, where that person was under 17 years of age at the time the offense was committed.

Under the above circumstances the Probate Court has jurisdiction only to convene a waiver hearing to Circuit Court or to dismiss the case if waiver criteria are not met.

Waiver proceedings in Michigan apply only to minors who are 15 years old or older at the time the offense was committed.

In this case, because the suspect was not yet 15 years old when the offenses were committed, but rather was 14 years old, the Probate Court has no jurisdiction to convene and entertain waiver

proceedings to adult court. Hence the case may not be filed in Probate Court by the prosecuting official or, if filed, would have to be dismissed by that court.

That is to say, under current Michigan law if the suspect had been apprehended after the 1989 offenses when he was still under 17 years old, Probate Court could not waive him over to adult court (because he was not 15 years old at the time of the offenses). In that situation, Probate Court would have to process him under Probate Court delinquency procedures, which do not allow adult criminal penalties (and do not now apply because the suspect is 17 years of age or older)."

After the mumbo-jumbo, there is no justice. For one year, I wanted nothing more than to kill this animal, who called himself an uncle. I was consumed with hatred for what he had done to Matthew. I wanted to spray paint his brand new car with the words "PERVERT" and "MOLESTER." I wanted to find him alone and beat the living hell out of him. I wanted to tell his girlfriends what he had done. I wanted to ruin his life for what he had done, and gotten away with. I wanted to call his parents, Gregory's parents, and tell them the sick human being they had raised. I wanted justice to be mine, and Matthew's, and could not have it.

I suggested counseling for Matthew; he was worried that what had happened would make him a homosexual. He was so ashamed for what he felt was his fault. He did go to counseling for a while but the counselor thought that he was handling it and did not need more than a few sessions. He seemed to accept the fact that he could not change what had happened, that it would not change his sexual preference when he was more mature, and that there was nothing more to do but go on with his life.

Pete would eventually apologize to Matthew, and Matthew would accept his apology. Pete would eventually go on to have a child of his own, a son, and that son would die at the age of three months, apparent crib death. When I heard the news, I did not rejoice, but the very first thought in my mind was, *an innocent for an innocent.* I know that sounds so cold, but was it karma? Was that the only way

Pete would pay for his sin? I felt bad, as I would for any parent that loses a child, but at the same time I felt that justice had been done. I'm not heartless but the violation of my son crystallized my heart with carbon dioxide snow, leaving it hardened with gaseous cold.

CATACLYSM

The deluge began on May 31, 1996. The torrential rain would not stop for what seemed an eternity. I received a call at work from Randy. My inner voice told me when the phone rang that it was for me, and it was something bad. I walked to the phone with that black ominous feeling I get when something doesn't feel right. Randy's words sent me to my knees. "Mom, Jeremy tried to kill himself."

My knees buckled and I screamed, "Not Jeremy!" I felt myself slipping into shock.

Randy said, "He's okay Mom, they're taking him to the hospital." I knew I had to do something but I couldn't get my brain to make my body move. I was on my knees screaming and crying with my boss and co-workers swirling around me. I couldn't get their faces to focus. I left the phone on the floor and walked to a sink to splash cold water in my face. I could hear a voice that sounded disconnected from me. "I have to go, I have to go home."

I knew I had to leave and go to Jeremy but I knew I couldn't drive myself. I wasn't functioning. One of my co-workers asked if I wanted her to drive me home. I couldn't think straight, I was so afraid my son was going to die before I got there. It was two days before graduation day; I was supposed to be going to his graduation from high school, not to the intensive care at a hospital a hundred miles

away.

I drove myself to the hospital and learned that Jeremy had swallowed 93,000 milligrams of aspirin. If it had been anything other than what he took, he would not have made it. I also learned it was because he was told the day before that he would not be able to walk with his class on commencement night because he was a half a credit short in a required subject. Jeremy hadn't told me the principal had informed him of this. It was a rule that wasn't always enforced and I believe Jeremy was a victim of discrimination and selective enforcement of a rule.

I believe there was jealousy on the part of the principal. Our sons were on the football team but his son didn't excel the way Jeremy did. He thought Jeremy had an "attitude." Jeremy was no different than any other jock, cocky but proud. Other students in the same position had walked with their graduating class in the past and all they had to do was make up the credit during the summer. Why not allow Jeremy the same honor? He had been a star football player all through high school. He broke records for yards rushing and touchdowns. He was on the Dream Team, the All State Dream Team, had an end-zone-to-end-zone touchdown, and scored all the points in one game they had won, with five touchdowns. He had represented the school with a winning spirit, always giving credit to "the team." He had maintained passing grades. He had done so much for the sports program, and in my eyes, the school let him down.

I know that Jeremy had taken the drastic step on his own; no one pushed him to do it. I was sorry he had the same suicidal tendencies I had in my past. I knew he had to take responsibility for his own actions, and I knew it was a cry for help. We never really know what is going through our kids' minds until it is too late. Jeremy had to deal with the extreme measure he had taken, try to solve his problems without those measures, and be a stronger person as a result.

Jeremy took those steps when he realized he had lived. He spent a week in a Depression/Anger Management Center, went on to make up his credit in summer school, and received his diploma, minus all the fanfare. He could never go back and walk with his classmates

but he accomplished the goal. I tried to file a lawsuit against the school, but they were protected by the federal government. Jeremy was not as bitter over the raw deal as I was. At the same time, I was so thankful I still had my son.

A MESSAGE FROM HELL

In August of 1996, I returned home from a softball tournament Randy was playing in. There was a message on my answering machine to call an officer at the city police station. My first reaction was to ask Matthew and Caleb if they had done anything wrong that I should know about before I called. They both said, "No." Before I got a chance to return the call, a neighbor girl called and said she needed to talk to me. Matthew babysat her five-year-old son. She and I were close; her son was like a grandson to me.

I walked over to her house and what she told me put me into a shock that came out of left field. I never dreamed in a million years that I would ever have to face something so appalling. She asked me if I had gotten a message to call the police and I said, "Yes." I wondered how she knew, and then she told me.

Matthew had babysat over the weekend for a relative of hers. He was so good with kids, and kids just loved him. She had recommended him because he was so good with her son. Matthew had just turned fifteen but was immature for his age. I did not know how immature until now.

The little girl had told her Daddy that she had a secret, and after talking to her, she told him that Matthew had touched her. At first they thought he had just helped her in the bathroom, but she said no,

he had touched her and wiped her. After talking to the six-year-old boy, the other parents learned that something had happened in an upstairs bedroom. I know how impressionable children are, and with the help of a parent questioning them, they usually tell the truth, but they also say what they think their parents want to hear. I believe the children told the truth, but I also believe some of the answers were suggested.

The neighbor was confiding in me because of our closeness. She had been advised not to say anything. I respect her for coming to me; it cushioned the shock of a mother's worst nightmare. She said she had already talked to her son, and she believed that Matthew had never touched him in an inappropriate way. I could not stop crying. Not only for what Matthew had done, for the innocent children involved, for the feelings of the parents, but for fear of what would happen to him now. The neighbor told me that one of the parents wanted my son tried as an adult. Being fifteen, I knew it was a serious possibility.

I walked home and called Hannah right away. She came over when she heard in my voice how upset I was. When she got there, I had already told Matthew that I knew why the police had called. I said, "You need to tell me what happened." He refused to say anything and ran upstairs to his bedroom. Hannah and I took a ride and I told her the shocking news. We cried together. I knew in my heart that Matthew had sexually molested those children when the neighbor first told me. I knew that what had happened to him with his Uncle Pete had an adverse affect on him. The cycle would not be broken. I also knew I would believe his side of the story, but it didn't make it any less significant.

As Hannah and I talked, we had to face the terrible realization that Matthew could possibly have touched other children he had babysat for, including Hannah's boy and girl, my grandchildren. We were both afraid to ask but we both believed he had not touched them. Hannah was in the habit of talking to her children about strangers and any inappropriate touching by *anyone*. She was convinced her children would have told her.

The next step would be the most difficult I would have to make. I had to return home, and place that call to the police. When Hannah and I arrived, Matthew was upstairs, in his closet, curled into a fetal position, and refused to come out. His tears were not only for fear, but for absolution of a terrible misdeed. Matthew is a good boy and I could not begin to understand what brought him to the point of his actions. Actions that I knew would affect and change his entire life. I was sickened to think one of my own could violate an innocent when his own innocence had been shattered in the same way. *How would I ever possibly get through this?*

I tried again to get Matthew out of the closet. My heart was ripping, weighed down with the weight of a mother's tears. I would do anything to protect my son, but I also knew I had to make him take responsibility for his actions. I quaked at the sight of my tall lanky son in the curled position of a defeated child. He was my flesh and blood, and I would stand with him and support him. I would not make excuses for his actions but I would help him carry the weight.

I called the police, told them I was returning their call, and informed him that I already knew what he wanted, and I needed his help to get my son out of the shell he was trying to hide in. If I didn't get him out of the fetal position, and soon, he may never be the same.

The officer came and talked to Matthew and he finally came downstairs. We sat at the dining room table and the officer took his statement, my stomach heaving with each sordid detail he revealed.

A SIGNIFICANT EXPLANATION

Before I reveal the facts of this delicate circumstance, I feel I must explain with as much sensitivity as I can, why I made the decision to reveal the facts at all. The dominate factor of abuse, the snag in the thread, is as much a part of my life as my soul is to my being. I have seen or felt from every aspect, the results of sexual abuse. My mother was a victim, I was a victim, my second husband was a victim, the sister he molested was a victim, my son was a victim, and the children he molested were victims. Are you a victim?

We, you and me, we all have secrets or made promises not to tell. You may still be living with a secret, or keeping a promise to protect an abuser or molester. I choose to be brutally honest, not only for healing purposes, but to encourage you to be strong enough to tell. The truth only hurts when we keep it inside and allow it to be our torturous demise.

I am not trying to minimize my son's actions. I am not trying to make excuses for his actions. I am not trying to pacify the anger of the parties involved. I am not trying to make amends for Matthew's actions. I am not trying to appease his guilt. Matthew has to live the rest of his life with the consequences for his abrupt, uncalculated decision to impact the life of an innocent. None of this changes the fact that he is my son, a piece of my being, embedded in my heart,

no matter what.

My son made a mistake in the immaturity of his youth. He is not a pedophile, seeking out children, lurking behind bushes, with uncontrollable urges to touch and violate innocent children. In the immaturity of his youth, he went through a process we've all been through; the process of discovering our uniqueness, seeking the answer to what makes a boy's body different from a girl. His mistake wasn't getting caught in childish games. His mistake was in giving in to the urges that all of us as humans go through. The hormone war that rages in boys and girls at the age of puberty is a normal process. For some it happens early in life, for others later, but we all have or will experience the same process. How we handle the process will either be appropriate, or be a mistake of taking the step over the line that violates someone's trust and will haunt us forever.

This matter did not go to adult court as the parties involved wished. It remained in juvenile court. It was never supposed to be revealed to the public but because of a change in the law, my son is now on a public internet list of offenders. Because of his name being a matter of public record, I feel vindicated in revealing some details of the police report and court proceedings.

All sides of their stories were the result of questions posed by a police officer. The children were not interviewed apart from each other, but in the same room, which may or may not explain the slight differences in each version of their story. One may have influenced the others response. I don't believe this procedure should have been used in this case. I think they should have been interviewed separately. I realize that with children, there is going to be a difference in views, but I also believe that one's view can be influenced by another's.

The questioning procedure is not fool proof for exactness when it comes to a child's view of any situation. They may pick up on an exaggeration of questions posed, especially with intimidating circumstances. No doubt, each parent believes their child's side of the story. It doesn't matter what the stories are, but the fact is that Matthew touched these children in an inappropriate way. He acted on the spur of the moment and against his better judgment. He went

with the spontaneity of the child in himself and not the responsibility and reasoning of the young man he should have been.

My son was labeled a child molester and a pervert. He was ostracized by parents who were told by police officers, *before* the internet list was public, that he was a molester. Their sons or daughters were not allowed to hang out with him. They were not allowed to walk down our street or come to our home. Matthew received a letter from a storeowner that forbade him entry into his store. The result, if he did, would be trespassing. The brother of one of the victims told all his classmates and Matthew was shunned. Mothers would see me in a grocery store and grab their children in a protective gesture, as if I would molest them. I was treated like a monster that created a monster.

I walked through my life living with the shame of what my son had done. I could not apologize, I could not make restitution. I could not turn back the clock and make it go away. I sensed what people were thinking, the words didn't have to be spoken. I wanted to run and hide and thought about moving away, starting fresh somewhere where Matthew was not known.

I feel what the children feel, I experienced it myself. I feel what the mothers feel, I experienced it myself. I understand the mothers wanting to kill my son; I felt the same emotion once. I understand them wanting to destroy his life, I felt it myself once. I empathize with their anger and the consuming rage they lived with, I knew the feeling myself. Everything I had felt for my son's molester, mothers were now feeling about my son.

IN THE SYSTEM

Matthew was arrested and released into my custody. He appeared in Juvenile Court, was appointed an attorney, and agreed to plead guilty to one count of Criminal Sexual Conduct. He still insisted he had only touched the girl, and I believed him. I had a hard time with his attorney, I felt like he did not explain to us the different degrees of CSC, and the punishment involved with each degree. We had several differences of opinions and it conflicted with the way he represented Matthew.

Matthew had never been in any trouble before this and I was convinced that an extended period of probation and counseling would be a sufficient way of handling this. It wasn't a matter of punishment, more a matter of getting help for Matthew so he would not become a repeat offender. As a juvenile, he could not get any jail time but there was the possibility of sending him to a boy's home. I also did not want it to go to any kind of trial. I did not want the children to have to go through the ordeal of telling their stories in front of any more people than they already had. I knew if they had to, it would be more trauma then they needed to bear.

Matthew was charged with both counts and was put on probation for three months, with a review hearing at the end of that time. He had to be evaluated by a psychologist and receive any therapy he

needed. The psychologist determined that Matthew was *very* immature for his age, being at the level of an immature twelve-year-old instead of the fifteen-year-old he was. He felt that he acted on the spur of the moment and that he would not have any long-term problem with being a pedophile. He recommended counseling with a local center.

During the probation period the court system decided to initiate a home-based counseling program that would include everyone in the household. I agreed to it until it became a major problem with Caleb, who was twelve. He could not have any of his friends over because Matthew could not have any contact with children under his own age. My grandchildren were not even allowed to come to my home. Caleb felt like he was being punished for something he didn't do. It wasn't fair that he had to be in on the counseling when he wasn't the one in trouble. I agreed.

I called the counselor and told her I refused to do the home program anymore but I would continue taking Matthew to his weekly sessions at the counseling center. She informed the judge of my decision and I was called into court on a contempt charge. He threatened to take my children away and throw me in jail for thirty days. I told him how I felt about the home-based sessions and how it was affecting Caleb, and it was not fair to him. I felt like my rights were being violated when I did not have any say so for what happened in my own home. Our home was the only place where we could feel like a normal family, without the influence of judgmental people. I was adamant and relentlessly told him that my rights were being violated. I was willing to go to jail to prove my point.

The judge relented and cancelled the home-based program for us. Matthew continued his weekly sessions for two months. He had a great deal of anger and unresolved issues remaining from his being molested, and the end results of his own actions. The counselor vehemently stressed that boys between the ages of twelve and fifteen should not under any circumstances be allowed to baby-sit. He passionately believed the hormone changes in boys of this age enhanced sexual tension and the need to experiment and discover

their bodies. It was too late for that advice for Matthew, his mistakes were already made, and his verdict was already in.

Weeks before he was due for the hearing to decide if he would be off probation, the brother of one of the victims had another boy follow Matthew home from school, knock him down into the bushes, and beat him up. Matthew defended himself. He was charged with a probation violation and his probation extended another six months. Just before the next review hearing, an incident happened at school with some boys harassing another boy and Matthew's name came up. The boy who was being harassed told the principal that Matthew was his friend and he was not involved. The boy's mother even went to the school and told them Matthew was not involved.

Matthew's name was included on a list of the boys doing the harassing and sent to the judge, and again his probation was extended. I started to feel like there was a conspiracy to keep my son in the system for a very long time. One of the children Matthew molested had a relative on the city police force and I believe Matthew's name was on the shit list, and this would not end until he paid his dues to the satisfaction of the enforcement brothers.

Matthew heard about some neighbor girls going into a vacant building and spraying the contents of a fire extinguisher. He and another boy went to look in the building to see what the girls had done. When the girls were found out and the police got involved, Matthew's name came up, again. When the police questioned him he stated that he and another boy had gone inside the building but only to see what the girls had done. They did not spray any extinguishers or damage anything.

Out of ten kids involved with going into the building, some spraying fire extinguishers, some doing other damage, all stated they had only *heard* that Matthew had gone into the building with another boy. The ones who did the damage admitted to it, but Matthew was charged, not only with Entering without Breaking, but also Malicious Destruction of Property. This extended his probation again.

One year after Matthew was placed on his initial probation; we were informed that he had to register his name on the sex offenders

list. We were told it was for police purposes only and it would *not* be a matter of public record, he would *not* be on the internet list. When he turned 18, his name was inevitably placed on the internet list, and it was a matter of public record, the laws had changed. Because he was charged with 2nd degree CSC, he qualified to be known to millions of people for a mistake and poor judgment as a boy. His debt to society was extended to a period of registering for the next twenty-five years, which includes verifying his address to the state police in person every three months for the next twenty-five years. Now people in our small town could verify what was whispered about to be true.

Matthew started drinking and ended up with four minor in possession charges and one possession of a controlled substance (marijuana) within a two-year period. He lost his driving privileges for three years. He paid hundreds of dollars in fines and court costs and did hundreds of hours of community service. Needless to say, because of his own actions or the mere mention of his name, he would be on continuous probation for a period of five years. He is now off probation, legal drinking age, and has never had a problem with being around innocent children. What began as one bad thing and led to another and another and another is finally over, he has paid his debt to society. Matthew is a good young man, he is still good with children, and children still love him.

STRIKE THREE

When Matthew was arrested for CSC, Mark was on the road. When I called him and told him what happened he assured me not to worry, he would get the money for a good attorney. He never came through with his promise, which is why Matthew had a court-appointed attorney. He said he would stand by me and help me get through this ordeal. He never came through on his promise. He let me down when I needed his love and support the most. He wasn't there for me and I had to handle everything on my own. Hannah was my support system, even though she was going through marital problems of her own. We held each other together.

Matthew had been babysitting for several other children and I called the mothers to tell them what happened, asking them to talk to their children, crying, and apologizing for having to tell them and to worry them. After each one talked to their children, and Hannah talked to hers, I was relieved to know that he hadn't touched any other innocents.

Mark stayed on the road, not wanting to deal with my emotions, not knowing how to deal with them. Everything he had done previous, all the times he had called me a bitch, throwing things at me, pushing me around, everything negative about him was now magnified in my eyes. I wanted to be rid of him. I wanted a divorce. I wanted to

color him gone. Any man who could not be strong enough to hold me together was not worth being with. He let me down in my darkest hour. If he expected me to handle it on my own, I would indeed be on my own.

I wasn't aware of when it happened, but somewhere along the line, now that I can reflect on it, I believe I had a minor nervous breakdown. I felt like I slipped over the line that separated sane and insane. I felt like I fell into a mystical world and I was living my life separate from my being. I started having faint premonitions that would come true. I would hear whispers of warnings within my mind. If I ignored them, circumstances came about that could have been prevented if I had listened to my inner intuitional voice. I learned to heed these occurrences.

I started talking to and confiding in a man who played on Randy's softball team. Our eyes met one day in such an intense look, I felt like I knew him in another time, and in that other time, we were in love. I can't begin to explain the power of the feelings. I saw him one time away from the ball field and I felt the overpowering urge to walk into his arms. I felt like I belonged there, that I had been there at another time, and that time was forever.

I called him that night and asked him, "Did you ever have the overpowering urge to walk into someone's arms?"

He said, "Yes, I felt it tonight."

He told me that shortly before he saw me walking toward him, he thought he saw me in the crowd, he felt my presence, but it wasn't me. Then out of nowhere, there I was, walking toward him, and he too had felt the overpowering urge to take me into his arms, even though he was standing there with another woman. We both felt like it would have been the natural thing to do, that we had always been in each others arms. We talked about it and neither of us could explain the forces of familiarity to each other. I would ache when I saw him with a woman. I could see myself sitting next to him, but it wasn't me.

He was so strong and understanding. We talked about many things, his children, my children, our childhoods (much of what is in this

story), our lives, our ancestries. We would talk for hours on the phone. Sometimes I would call him in the wee hours of the night. He was always there for me, no matter what time it was. Everything he told me I felt like I already knew; that I had gone through his life with him. I always felt his presence. I knew when he would be coming down the road, even before I saw him. I would pick up the phone and call him and so many times he would say, "I was just about to call you." Sometimes he would call me just as I was about to pick up the phone. I would talk and he would listen. I would cry and he would comfort me. I would ask for advice and he would give me his unbiased opinion. When we talked on the phone I felt like I left my body and went to him or I brought him to me.

I don't believe in reincarnation but I do believe that our lives had crossed paths in some other time, a time that was in abeyance. Our hearts were connected and neither of us knew how it was humanly possible. If he felt pain, I knew it. I always felt like my soul was weeping for wanting to be near him, but I also knew we would ultimately never be together, even though we were. He felt the same mystical awareness and it was uncanny. He was a soothing force in my life. He was salve in my wounds. He was comfort in my distress. He was calm in my storm. He still is, but from a distance.

I had told him that Matthew was in trouble but I was too ashamed to give him the details. In time I did tell him. He said, "I knew you wanted to tell me and I knew you would in your own time." He never judged Matthew for what he'd done. He understood how an adolescent can react in situations like Matthew had placed himself in. He knew the difference between a mistake and a crime. He understood and eased my pain. He understood when I told him the little boy was six-years-old. He even understood when I told him about the little girl. She was four-years-old.

THE PARALLEL

One of the most difficult decisions for me to make was using the parallel between the beginning and the ending. It begins with a four-year-old girl that was left with internal scars. I can only hope that the other little girl will forget. I can hope that she does not repress the memory, and relive it at sixteen the way I did. I can hope that if that happens, she can forgive. Please do not judge my son. He has made amends for his mistake by not repeating it. He has lived with the guilt of his actions and I hope he never has to live his karma by having to give up an innocent for an innocent.

The snag in the thread, the abuse that flowed along with me through my life has ended. I look back and am sickened by the abuse I survived in my relationships and marriages that consumed half of my life. Each form of abuse, physical, emotional, and sexual, have made me who I am today. I am no longer a victim, an emotional cripple or a moth caught in the clutches of a killer spider's web. I struggled my way to the freedom I have today. I bore the cruelest imprisonment that I was able to bear and know others that bear worse. I did not lose my sanity, or my life. I never gave up hope that I would finally be released from a cocoon, breathe free air, and fly away with graceful wings. Tuesday's child really is full of grace.

When I broke through the claustrophobic circle that held me

captive, I knew I would never again put myself in a situation with any man that would give him the freedom to oppress me into a nothing. My motto became "No second chance." The first sign of abuse, the first sign of unfaithfulness, the first sign of control only merits one word: good-bye. No man has the right to touch my body unless I give him that right. No man has the right to control my thoughts, emotions, responses, or actions. I am me and have the freedom to be who I am.

When I gained my freedom, I was ragged and jagged, but free. I reshaped all the jagged edges that resulted from being snapped in the wind like a shower curtain on a brisk winter's day. I hunted for each piece and carefully placed them together in a smooth reunion of my body, soul, and spirit. I am happy and content. My four-year-old self is finally resting peacefully in her little niche of serenity. She no longer haunts me, rambling through my mind, begging to be let out of the closet. She is silenced with justification.